POSTCARD HISTORY SERIES

Around Walterboro

South Carolina

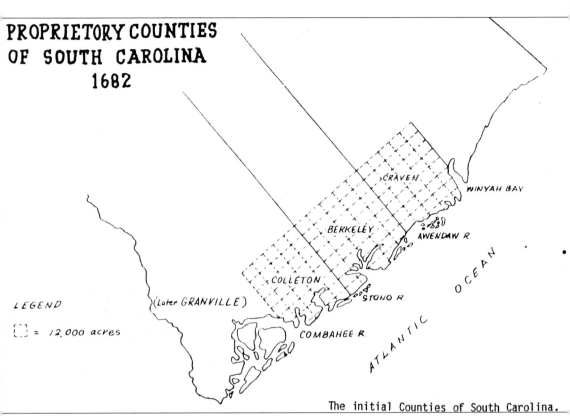

PROPRIETORY COUNTIES OF SOUTH CAROLINA 1682

CRAVEN

WINYAH BAY

BERKELEY

AWENDAW R.

COLLETON

(Later GRANVILLE)

STONO R.

COMBAHEE R.

OCEAN

ATLANTIC

LEGEND

☐ = 12,000 acres

The initial Counties of South Carolina.

The three original counties that were laid out for the Lord Proprietors were Colleton, Berkeley, and Craven. The eight noblemen controlled the land collectively. Sir John Colleton, who was instrumental in obtaining the land, never came to Carolina himself, but his son lived here for a short time and his great-grandson spent his lifetime in the area and is buried in Biggins churchyard in Berkeley County.

POSTCARD HISTORY SERIES

Around Walterboro

South Carolina

Sherry J. Cawley

ARCADIA
PUBLISHING

Published by Arcadia Publishing
Charleston, South Carolina

Printed in the United States of America

Library of Congress Catalog Card Number: 98-87568

For all general information contact Arcadia Publishing at:
Telephone 843-853-2070
Fax 843-853-0044
E-mail sales@arcadiapublishing.com
For customer service and orders:
Toll-Free 1-888-313-2665

Visit us on the Internet at www.arcadiapublishing.com

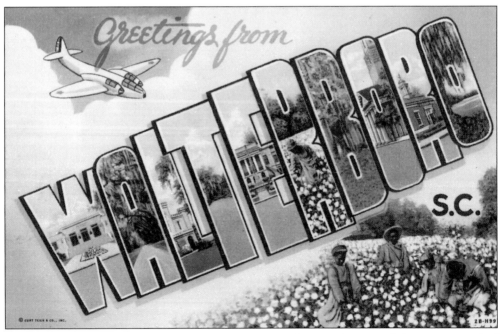

This linen large letter card of Walterboro shows an airplane in the upper left corner typical of many of the planes at Anderson Field during World War II. The area became an Army Air Base for training the Air Corps and also served as a POW camp. Cotton was a major crop for Colleton County for many years. The image in each of the letters can be found throughout this book.

CONTENTS

ACKNOWLEDGMENTS

Remember the old story, "We've got lots of talent. We've got a barn. The school band needs to raise money for new uniforms. Let's do a show!" Here's the updated version: "You've got a wonderful collection of Walterboro postcards. We've got a publisher that might be interested. The Colleton County Historical and Preservation Society needs to raise more funds to help restore the Bedon-Lucas House, *c.* 1820, purchased last year. Let's do a book!" Thanks, Budd!

A project of this scope cannot be done without the generous help and support of many people: John Till, Budd Price, John S. Hiott, and Robert Stets allowed me to peruse their postcard collections and use whatever was needed; Howard Woody loaned us cards from his extensive collection on South Carolina; Mr. and Mrs. Carleton Burtt let us borrow an early card of the McTeer house, which is now their home.

We would like to give a special thank you to Ernest Ferguson at Photo Arts, Inc. in Winnsboro, South Carolina, for allowing us to use five of the cards he published in the 1950s.

Numerous real photo cards came from the family albums of Helen Fraser Weissenstein, Gail Ilderton Couch, John Lucas, Raye Cook Murdaugh, John S. Hiott, Budd G. Price IV, Ida Sauls Hiott, Edna Sams Lewis, and Walker Breland. Many of these people graciously shared their family histories as well.

A sincere thank you is extended to everyone who took the time to share early memories of Walterboro with me, including Fripp and Annie Ruth Fishburne, Marguerite Crosby Smith, Charlotte Crosby Jordon, Tom McDaniel, Don Pool, John S. Hiott, Sam Siegel, G. Michael Hadwin, and Bernard Warshaw. Robert Stets permitted us to use three of his printed maps of early Colleton County.

We also thank the Colleton County Chamber of Commerce for allowing us to reprint a city grid used a few years ago, Chris Helms and the *Press and Standard* newspaper for giving us excellent coverage on various stages of the project, the staff at Colleton County Memorial Library for always suggesting and finding more interesting items to research, and Laura Lynn Hughes for all her time and vigilance in keeping me "historically in line." Our goal was to be as historically correct as we possibly could.

Recognition should be given to some of the sources in the bibliography. The writings of Miss Beulah Glover were invaluable. Suzanne Cameron Linder's Historical Atlas of the Rice Plantations was an exceptional undertaking. It really organizes a wealth of information from many sources. I found *The Edisto Book* by C.H. Wright and *Edisto, A Sea Island Principality* by Clara Childs Puckette particularly helpful. While all the books, papers, pamphlets, and newspapers listed were utilized, the most consistently used source was the *Colleton County, South Carolina: A Pictorial History* by the Colleton County Historical and Preservation Society.

A warm thank you is extended to the Colleton County Historical and Preservation Society that celebrates its 40th anniversary in 1998. The Society has done a phenomenal job over the years of preserving the extraordinary history that is Walterboro and Colleton County. I appreciate your allowing me to be a part of that process.

This book would never have been written if my husband, Richard, who was born and raised in Walterboro, and his mother, Willie Mae, who was a resident of Walterboro for over 60 years, had not taught me many years ago that when God stopped in the Lowcountry of South Carolina, he liked it so much he stayed. Don't take our word for it. Ask anyone who lives there now, has lived there in the past, or plans to live there in the future. Because of them I added Walterboro and Colleton County to my postcard collecting.

INTRODUCTION

When Charles II became King of England in 1663, he showed his appreciation to eight of his loyal supporters by granting them the land of Carolina. Sir John Colleton, a planter in Barbados, West Indies, used his influence with the new king to obtain the land grants of Carolina for these Lord Proprietors. In 1682, three counties—Berkeley, Craven, and Colleton—were laid out for development. Though many changes have occurred in its size and shape, Colleton remains the fifth largest county, with 1,050 square miles, in the state of South Carolina.

The settlers in Colleton County discovered that this territory was ideal for planting various crops such as indigo, rice, and later cotton. Around 1740, Jacksonborough was one of the earliest trading centers on the Edisto River. It later became the county seat of Colleton County. As the plantations evolved, the river trunks necessary for the rice fields created stagnant water, which brought mosquitoes that carried malaria.

In 1783 two brothers, Paul and Jacob Walter, began a desperate search for higher ground that would provide good soil drainage and freshwater springs to bring their families during the summer months. Paul Walter had already lost 11 children to malaria and his young daughter had taken ill. They traveled by horse up Ireland Creek about 18 miles and stopped in a hickory grove to rest. As they looked around, they discovered the "valley" had sandy dry soil, the pine and hickory trees provided lots of shade, and the water from a nearby spring was cold and pure. They immediately went home and moved their families to the area. Paul Walter's young daughter, Mary, improved her health and was soon playing with the other children. Mary Walter lived to the age of 76 and is buried at Whitmarsh Plantation between Neyles and Jacksonboro.

Presently other Lowcountry planters heard about the healthy conditions in Hickory Valley. Each year more summer homes were built, and the summer colony of Walterborough was established. Before long, people were staying year round. In 1817 the General Assembly designated Walterborough as the county seat. However, it wasn't until the fall of 1822 that the courthouse and jail were completed.

By 1866 the population of Walterboro had grown to about 834 people. The 1920 population census increased the town to 1,872. While basically remaining a farming community, a change occurred in Walterboro as the country began to improve the roads leading from the North to the South. Walterboro was the halfway point on the shortest route from New York City to Miami, Florida. From the 1930s through the 1950s it became a haven for travelers who returned year after year. According to a 1950 Walterboro Business Directory, with a city population of only 4,600, there were 4 hotels, 9 tourist homes, 19 tourist and trailer courts, 2 theaters, 1 drive-in theatre, about 28 restaurants, cafes, and snack bars, 6 drugstores, and over 30 places to service your car. Today many of these businesses are gone, but some buildings remain. With the postcards in this collection, we've tried to let you know how the space is now being utilized.

Before the days of expressways, chain motels, and fast food restaurants, it is amazing to realize that this small Southern town established itself as "The City of Hospitality." Without a doubt Walterboro was THE PLACE to spend the night between New York and Florida. Today, Walterboro still encourages the traveler to spend the night in town or a week on Edisto Beach and partake in the charm, the many historic places, and Southern hospitality that exist in Colleton County.

Many of the small communities in the county have disappeared or become crossroads along the highways. Presently, the main towns and communities include Ashepoo, Ashton, Bells Crossroads, Bennett's Point, Canadys, Catholic Hill, Cottageville, Doctor's Creek, Edisto Beach, Green Pond, Hendersonville, Islandton, Jacksonboro, Jonesville, Lodge, Mashawville, Neyles, Ritter, Round

O, Ruffin, Rum Gully, Smoaks, Snider's Crossroads, Stokes, Sydneys, Walterboro, White Hall, Wiggins, and Williams.

There are less than 20 plantations still standing or restored. Many sites and plantations have become part of other counties. However, almost all the postcards in this book represent places that at one time were a part of the original land granted to those eight Lord Proprietors so long ago.

About Postcards

Deltiology, the study of postcards, has been going on since the first governmental postal cards were produced by the Austrian government in 1869. In 1873 the first postal cards were released in the United States in New York, Boston, and Washington, D.C. In 1898 the U.S. government declared that all postcards, those published by the government and those produced by private publishers, would be charged the same amount for mailing. Pictures could now be added to one side of the card with the address on the other side.

Before World War I, millions upon millions of cards were mailed each year throughout America and Europe. Today, accumulating postcards is one of the top three collecting hobbies. To help you enjoy this book, we'd like to share with you how we observe a postcard. First, we look at two things on the card: 1) the type or style on both sides of the printed card; and 2) the image or view on one side of the card. These can tell us the age of the card and where it was published. Generally, there are six eras of postcard publishing that describe how the card was produced and formatted. Remember, the dates are approximates and there is much overlapping. The six eras are as follows: Pioneer, 1869–1898; Golden Age, 1898–1915; White Border, 1915–1930; Linen, 1930–1949; Chrome, 1949–1970; and Modern, 1970–present. Prior to the 1960s, postcards were generally published as 3 1/2" x 5 1/4" in size. Today postcards published by private companies are 4" x 6" or larger. Only pre-stamped postal cards remain in the smaller size.

While you can't observe the back of the cards here, some things to look for include the following: the divided back, which was established in 1907, allowed for a message to be shared with the space for the address; a postmark date; the postage stamp; or the zip code, which didn't begin until 1943 and had only two digits until 1963.

Some things to notice on the front of the postcard include the following: buildings, if they still exist, their architectural design, and how they look today; transportation, from horse and buggy to automobiles; dress fashions of people; roads, whether they are dirt, clay, or paved; bridges, style and how they are made; format or style; and artistic, whether the card was produced by the artist or made while the artist was still alive. Many publishers used a number/letter code to determine the date. For example, Curt Teich Co., Chicago, used letters to indicate the decade when a card was printed: A-1930s, B-1940s, C-1950s.

Deltiologists are fond of saying that anything and everything can be found on postcards. A postcard dealer will have his inventory divided into hundreds of topics. The general theme of this book is Walterboro and Colleton County, South Carolina. The different topicals or subjects found herein include the following: views, street scenes, greetings, exaggeration, large letter, court house, schools, Art Deco, artist signed, banks, automobiles, tourist homes, hotels, tourist or motor courts, restaurants, post office, lovers, railroad depot, bridges, rivers, churches, theaters, retail stores, advertising, humor, black, Coca-Cola, real photo, political, flowers, trees, maps, pen or crayon sketches, gas stations, houses, plantations, linens, and chromes.

By collecting postcards and studying the age and the topic of each card, we have an imaginative and fun way to study history. They also generate memories, stories, and debates. We hope you enjoy viewing these postcards as much as we've enjoyed collecting them.

One

A SUMMER RETREAT

Hickory Valley, which was about 5 or 6 acres in size, was the first part of the Walterborough area that was settled by Paul and Jacob Walter in 1784. As more plantation owners built homes around the Valley, the section gained the reputation as a safe place from malaria during the hot summer months. It wasn't until 1826 that the town was incorporated. The first major natural disaster was the cyclone of 1879, which decimated most of the town. In 1886 the Charleston earthquake damaged some buildings in Walterboro, and the hurricane of 1893 caused some major destruction. Most of the cards seen here were made prior to 1920 and show typical early scenes of Walterboro as it changed from a rural village to a small town.

The tennis courts, shown here, are on the estate of Richard M. Jefferies, who served in the state senate for many years. In March 1942, Governor Harley died in office and, as the president pro tem of the senate, Senator Jefferies became the governor of South Carolina until January 1943. He chose not to seek re-election and continued to serve in the senate. Much of the progress in Walterboro and Colleton County can be attributed to Senator Jefferies.

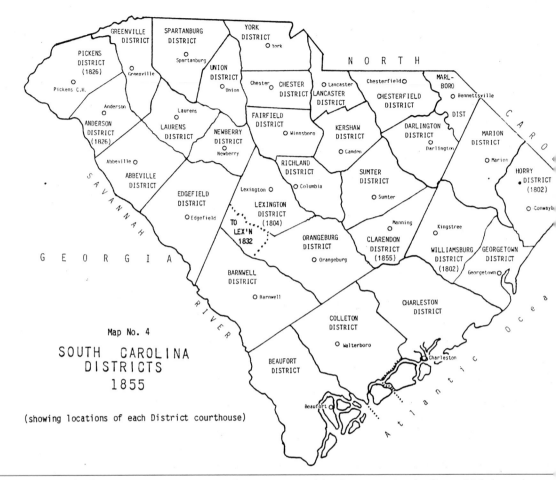

Map No. 4

SOUTH CAROLINA DISTRICTS 1855

(showing locations of each District courthouse)

Typical of any new territory, many changes occurred in the governing bodies, which brought about change in the size and shape of the areas. The Lowcountry has shifted from counties to parishes to districts and back to counties, constantly changing the land proportions. This map indicates that in 1855 the Lowcountry consisted of Beaufort, Colleton, and Charleston Districts. You will notice that all of Edisto Island was part of Colleton County at that time.

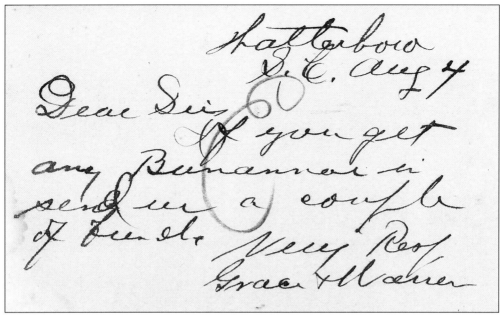

As the earliest card in the collection, this postal card is dated August 4, 1905. Ads were found in the *Press and Standard* newspaper in 1902 and 1904 for "ladies and gents clothing at manufacturers prices, fruit, toys, candy, glassware, china and fresh eggs." The advertising was signed Grace & Warren. Obviously, everyone in town knew who they were and where the store was located.

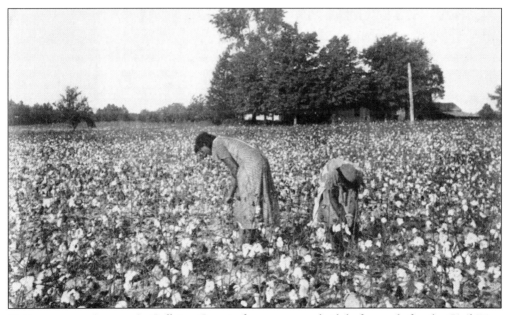

Cotton was a major crop in Colleton County for many years both before and after the Civil War. It was almost always picked by hand. Up into the 1950s there were still four cotton gins operating in the county, which were located in Cottageville, Islandton, Round O, and Smoaks.

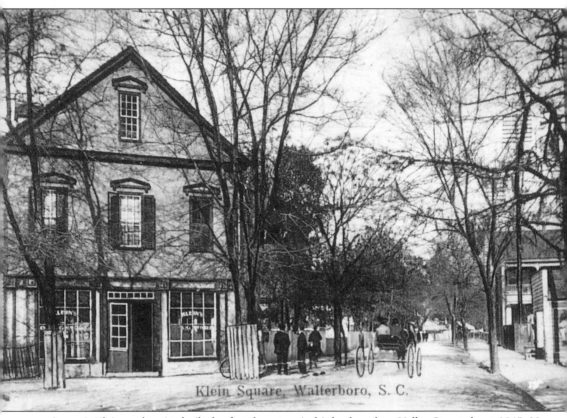

Klein Square, Walterboro, S. C.

James J. Klein, a chemist, built the first drugstore in his backyard on Valley Street about 1845. He later rebuilt the store at the corner of Main Street and Railroad Avenue. It marked the division of uptown (to the west) and downtown (to the east) Walterboro. When the cyclone of 1879 destroyed their home, the family moved into the second story of the shop. Dr. Jim von Lehe bought the doctor's offices that Dr. John M. Klein, the son, built behind the drugstore. "Klein's Square" became the gathering place for local men to gossip. The drugstore was torn down in 1959 and replaced with a single-level brick building that now houses Delta Loans. The two-story building on the right was Hubster's Bakery (the family lived on the second floor), known for their fresh bread and coconut macaroons.

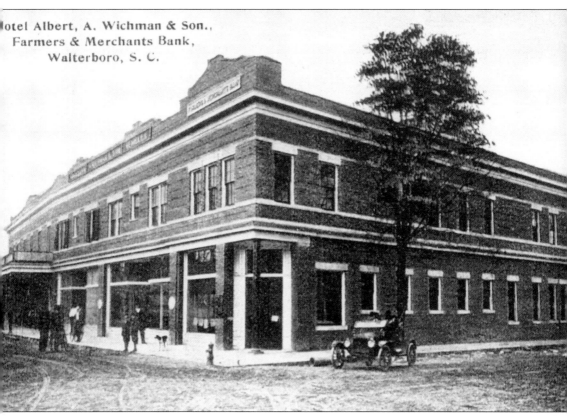

Hotel Albert, A. Wichman & Son.,
Farmers & Merchants Bank,
Walterboro, S. C.

This building, owned by the Wichman family, housed the Hotel Albert, the hardware store of A. Wichman & Son, and Farmers & Merchants Bank. It stood at the corner of Main (Washington) and Walter (Wichman). Many street name changes have occurred over the years. Please see city grid on page 56 to review them all. Western Union had an office on the Walter Street side of the building. For many years the hotel was known as the Cooper-Reed Hotel before it was changed to the Lord Colleton Hotel. There was a hotel dining room that could cater to dinner parties, and Hotel Albert was one of the first places to have steam heat in each room. The area from the dining room to the bank has recently been renovated as the Shoppes at Albert House, with some apartments upstairs.

The picket fences indicate that homes were still being built on Main Street. Finn's Jewelry in the right-hand corner had an ad in a 1904 edition of the *Press and Standard* advertising solid gold rings, scarf pins, silver cuff and collar buttons, and broaches. Later they advertised for Edison Phonographs starting at $10 and records for 20¢ each.

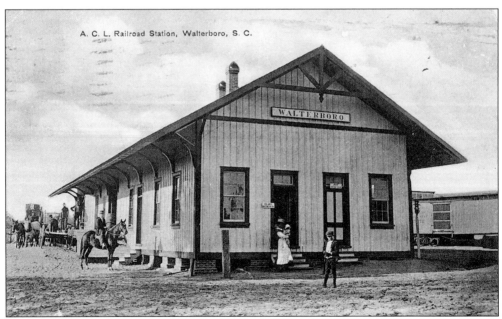

The Atlantic Coast Line Railroad Company connected Walterboro to their main line at Green Pond, 12 miles away. From there one could travel to Charleston or Savannah, Georgia. They had daily freight and passenger service. Early schedules show the train leaving Walterboro at 7:00 a.m. and 1:35 p.m. The conductor was known to look down Railroad Avenue to make sure there were no late stragglers who might miss the train.

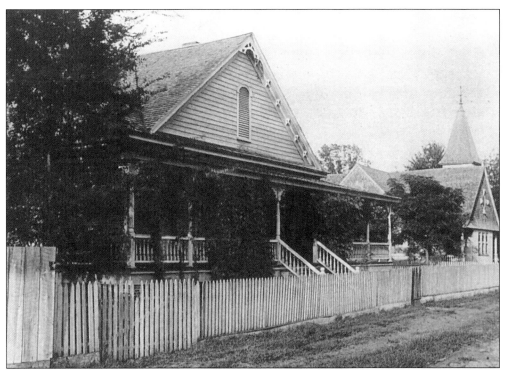

This property on Neyle Street was donated by Mr. Benjamin Sanders to the First Baptist Church. The church was destroyed by the hurricane of 1893 and the rebuilding was completed in 1897. The congregation stayed here until 1954 when they bought the Mary Glover property at Memorial between Carn and Hampton Streets and built a much larger church. This church has been used by various congregations since then and is currently for sale.

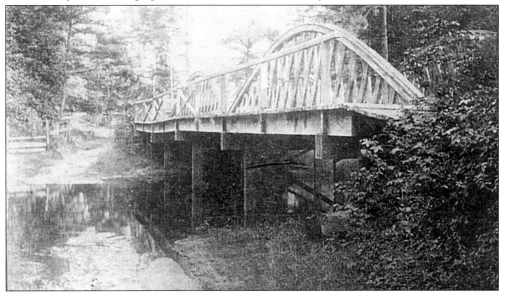

This postcard, postmarked 1907, shows the bridge on the main road coming into town from the north when it was still a high wooden structure. When you passed over Ireland Creek, the Lafayette Highway became Bridge Street. At one time the bridge indicated the city limits.

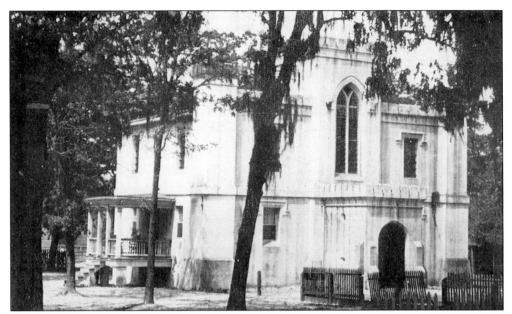

The third jail building in Walterboro was completed in 1857. This Gothic structure was designed by the architects Jones and Lee and constructed by Jonathan and Benjamin Lucas. The jail included living quarters for the jailer and his family until 1937. About that time a new jail was completed behind this one on Brown Street. When this building was renovated, the side porch was removed and offices were added to the back.

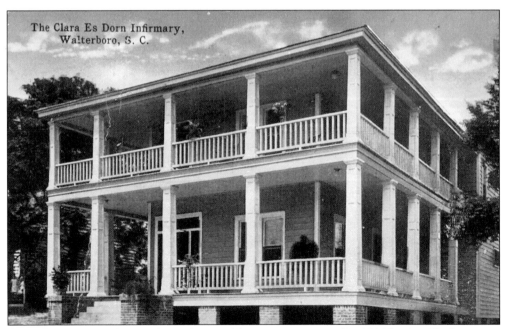

The Clara EsDorn Infirmary, located on Webb Street, was opened in 1911 by Dr. Charles Henry EsDorn, who named the facility after his wife. Clara EsDorn was a graduate nurse who helped develop the training facility for nurses at the infirmary. Paul Walter, one of the original settlers of Walterboro, had built his home on the hill next to the infirmary.

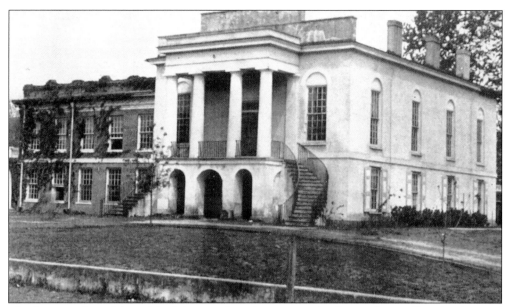

The front portico of the original County Courthouse is credited to Robert Mills, who designed the Washington Monument and many other South Carolina courthouses. The structure shows the four Doric (which are plain and unfluted) columns and the matching curved staircases leading to the second level. The center section was completed in the fall of 1822.

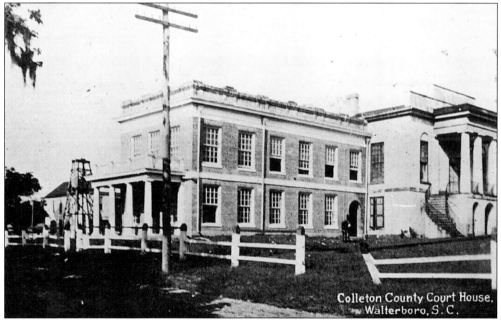

In June 1828, Robert Barnwell Rhett, a local lawyer, gave the first public speech on the nullification theory at the Courthouse. He stated that the high and unjust tariff against the agricultural South should be null and void. The west wing was added to the Courthouse in 1900. In 1909 the tower for the first city water tank, seen on the left, was started on the Courthouse Square.

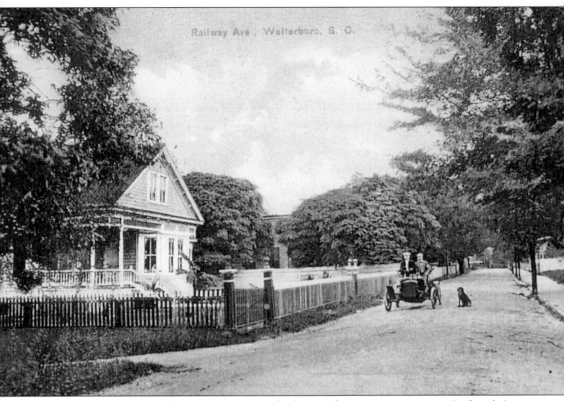

There never was a Railway Avenue in Walterboro. The correct name was Railroad Avenue, which ended at the ACL Railway Depot. The house on the left was built by Ben Levy about 1901. The Given's family bought the house in the early twenties. Unfortunately, it burned down in 1988. The "twin houses" built by A.H. Wichman *c.* 1881 were next to this home. Later one of the houses was owned by Dr. Duncan Pagdett. Railroad Avenue was paved in 1921 along with some of the other major streets in Walterboro.

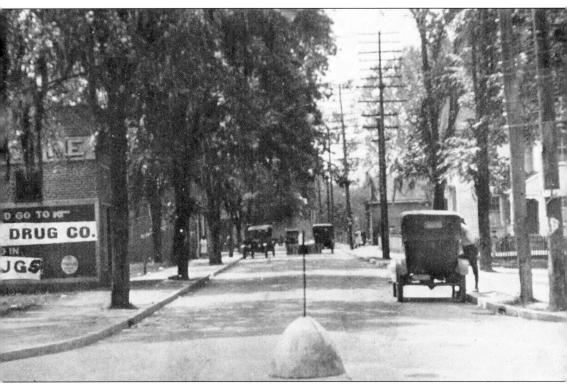

Guess what? There never was a Colleton Avenue in Walterboro either! The marker on the center of the postcard was in front of Klein's Drug Store looking up Main Street. On the right one can view the Whitsel house and on the left was the Walterboro Drug Co. sign. The Walterboro Pharmacy was changed to the Walterboro Drug Co. in 1904 when E.M. Jones and Dr. Riddick Ackerman bought the company. They first moved into the building that was formerly used by Mr. Jones as a millinery department store. The drugstore occupied various locations on Main Street. The last location was adjacent to the old post office and for many years was owned by Dr. Harry Cone and his family. They have recently sold the business to Eckerd's. Today the building is empty.

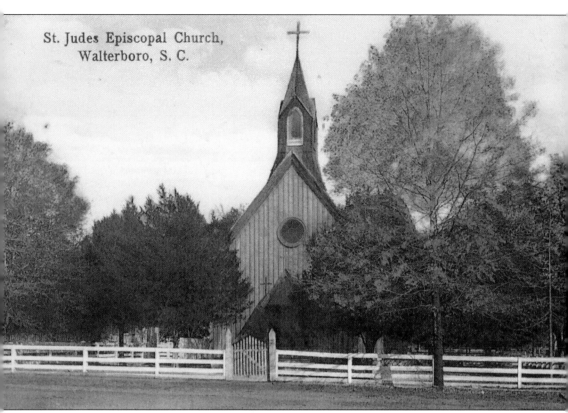

St. Judes Episcopal Church,
Walterboro, S. C.

The original parish of St. Jude's Episcopal Church was comprised of plantation owners of St. Bartholomews Parish and was established in 1706. The first church was built near Jacksonborough in 1725 and called the "Pon Pon Chapel of Ease." Because of the summer influx of residents, the church decided to build a structure in Walterborough, and it was completed in 1826. Worship services for St. Jude's were changed from Jacksonborough to Walterborough in 1832. In 1855, St. Jude's was created into an independent parish from St. Bartholomews Parish, and a larger church replaced the smaller one, but it was destroyed by the 1879 tornado. This Carpenter Gothic structure was completed in 1882.

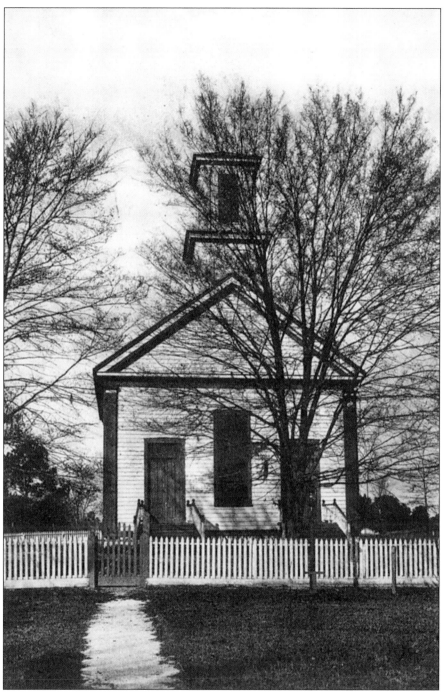

The first Bethel Presbyterian Church in Colleton County was established near Jacksonborough in 1728 by Archibald Stobo. When the trustees of the church decided to build a summer chapel in Walterboro in 1822, they chose the hillsite where Paul Walter had built his original house. According to the the state historical marker placed at the first church by Colleton County Historical and Preservation Society, the congregation moved early in the nineteenth century and a woods fire destroyed the old church building in Jacksonborough in 1886.

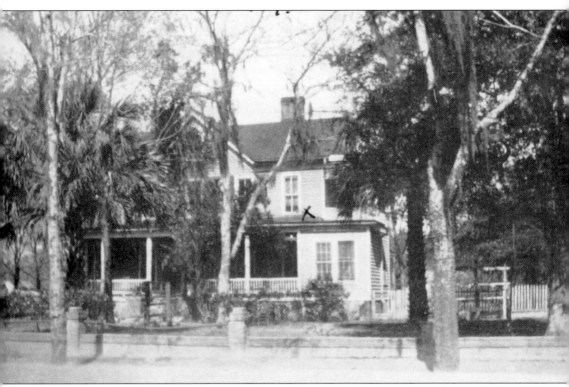

The lovely Palmetto Inn was originally built in the late 1800s by Alexander C. Shaffer, who came to Walterboro after the Civil War while working for the Freedman's Bureau. He was a co-founder of Terry and Shaffer Department Store. The house was converted into an inn for tourists and boarders. The Palmetto Inn was located on Main Street and managed by Mr. and Mrs. Cliff Crosby until it burned in 1927. The new post office has been built on the property.

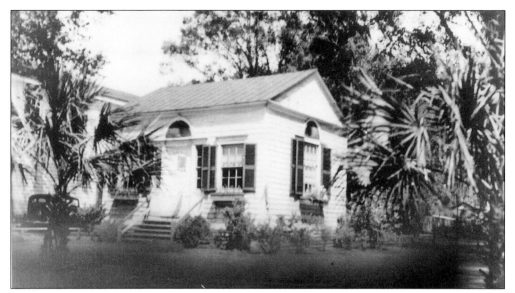

The Walterborough Library Society was established in 1820, and the South Carolina General Assembly granted it incorporation in 1821. The small frame structure was designed in the Federal style. The original site of the building was on the site of St. Jude's Episcopal Church. When Archibald Campbell surveyed the area for incorporation in 1826, he used the Little Library as the center of town and everything 3/4 mile from it became the city limits.

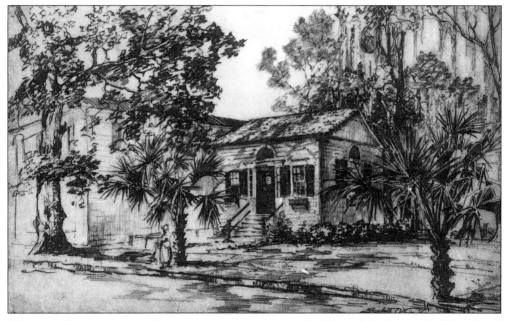

When the library was moved onto the property donated by Richard Bedon, the building faced Wichman Street. It was turned to face St. Jude's in 1957, when it became the headquarters of the Colleton County Historical Society. Elizabeth O'Neill Verner, a well-known Charleston artist, drew this etching. A number of her original paintings hang in the Gibbes Museum in Charleston. Next to the library was one of the first stores in Walterboro, constructed by Ezra Miller.

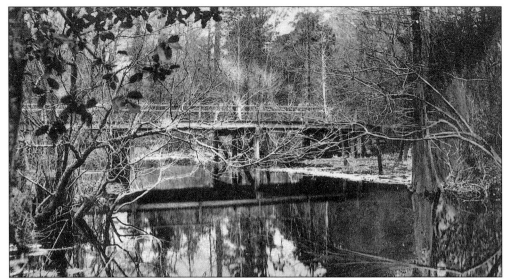

Here we see the Ireland Creek bridge when it was still made of wood with a dirt road and later, when it was changed to concrete with a clay road. The creek was originally known as Island Creek and for many years had a local swimming hole and was wide enough for fisherman to use their boats to fish. Due to some damming work done on the Edisto River, Ireland Creek narrowed considerably. Nevertheless, what was once a narrow bridge over a wide creek has changed today into a wide bridge over a narrow creek.

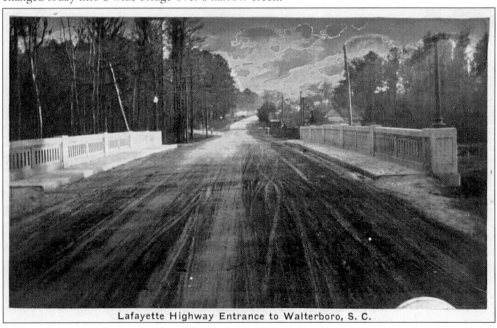

Lafayette Highway Entrance to Walterboro, S. C.

Two

THE COUNTY SEAT

After Walterboro became the county seat in 1817, there was a natural growth in the city and county government structures, businesses, schools, and churches. By the late 1800s major business districts included Wichman Street, East Washington Street, and Railroad Avenue near the depot. As automobiles became more popular than horses, both national and state highways were paved. The Coastal (U.S. 17) Highway led to Charleston and Savannah, Georgia. The Lafayette (U.S. 15) Highway came south from Raleigh, North Carolina, and merged in Walterboro with the Coastal Highway.

The town enjoyed daily bus service on the Camel City Lines and later Greyhound. The Atlantic Coast Line Railway came into town twice daily. Outdoor recreation in Colleton County encouraged people to come back year after year to hunt quail, deer, wild turkeys, and green-head mallards or fish her fresh and saltwater rivers and marshes.

Truck farming became very profitable in the 1930s and is still done today, shipping crops to the Northern markets during the winter and spring months. During the 1930s and 1940s, Walterboro also enjoyed an industrial growth. By 1950 over 50 different products were manufactured in Colleton County.

For over 25 years, the County sponsored a week-long fair that was held at the old fairgrounds, which is now occupied by the Bulldog football stadium. For the past 23 years, the City has sponsored the Annual Rice Festival, held on the last weekend of April on Washington Street and the Courthouse Square.

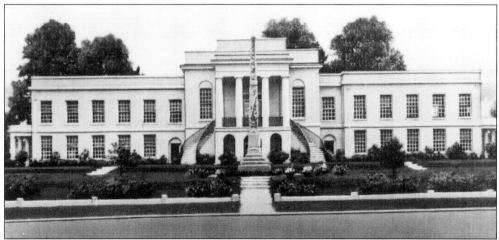

The Courthouse, which stands at Jefferies Boulevard between Washington Street and Hampton Street, dates back to 1822. This view is facing Hampton.

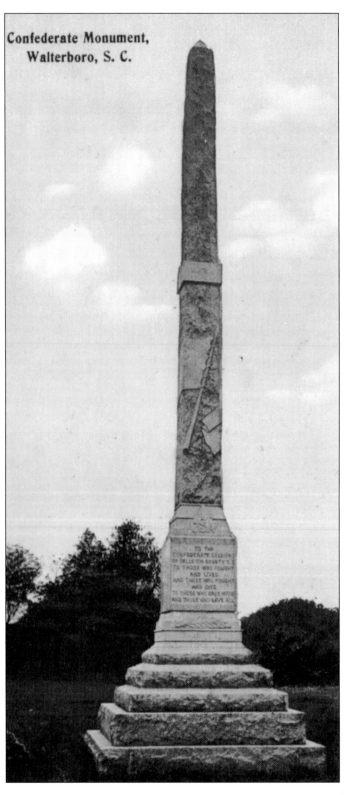

Confederate Monument,
Walterboro, S. C.

On June 22, 1911, the Confederate Veterans of Colleton County dedicated the Confederate Monument on the Courthouse Square. The 32-foot structure cost $1,000 and over 50 Confederate veterans were in attendance. The first inscription says, "To the Confederate Soldiers of Colleton County; To those who fought and lived; Those who fought and died; To those who gave much and to those who gave all." The second inscription states, "To the mothers, wives, sisters and daughters of Colleton County who fought the home battles of 1861–1865." The monument has been in three locations around the Courthouse. As the postcards indicate, it has been at the corner of Jefferies Boulevard and Hampton Street, on the corner of East Washington and Waters Street across from the old Vogler Hotel, and in the center of the Courthouse facing Hampton Street.

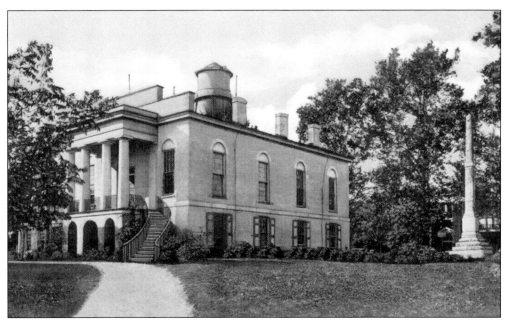

The East Wing of the Courthouse was added in 1939. It was designed to match the West Wing, but you can see the difference if you look hard enough. The columns face Hampton Street. What is unique is that the twin curved iron staircases are rustproof. A single courtroom almost covers the entire second floor of the original building. Behind the East Wing you can see the *Press and Standard* building on East Washington Street. Look carefully to see the completed water tower that was across the street from the *Press and Standard*.

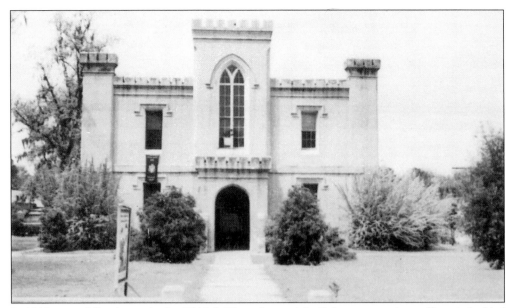

In 1937, remodeling began in the Old Jail. They changed the living quarters into offices and added more rooms onto the back of the building. The structure became the office building for the county government. Today the building houses the Colleton County Museum and the Colleton County Council Chambers. The annex houses the Walterboro-Colleton Chamber of Commerce.

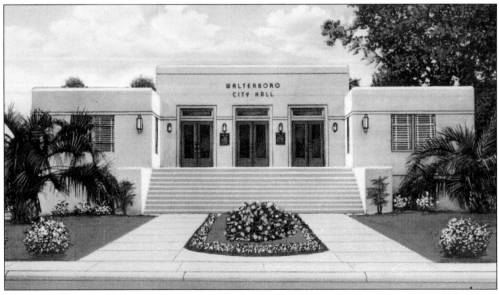

This structure on Hampton Street was built in 1940 as a WPA project. As with many of these projects, it was designed in the Art Deco motif. In 1975 City Hall was remodeled with a Palladian facade of four Doric columns and twin curving stairs to complement the Colleton County Courthouse.

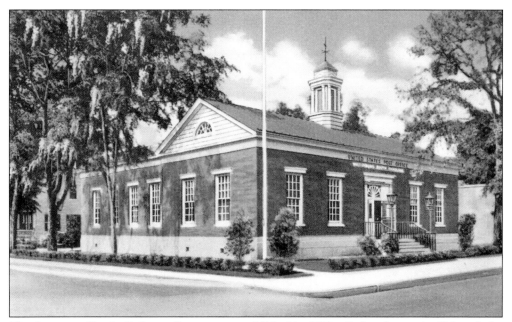

The first post office in Colleton County was established in 1793 at Jacksonborough. Although the first postmaster was appointed for Walterboro in 1820, the first known post office building was a small store on East Washington Street near Wichman Street. In 1893 the post office officially changed the spelling of "Walterborough" to "Walterboro."

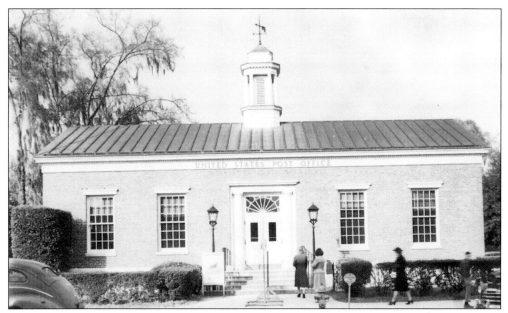

After World War I, the post office moved up East Washington Street into the lower level of the Masonic building. This post office building was another WPA project built in 1937. Inside, Sheffield Kagy, a WPA artist, painted a mural scene showing Lowcountry plantation life. The post office remained here until 1986, when the new enlarged post office was dedicated. Today the building houses the Canady Agency.

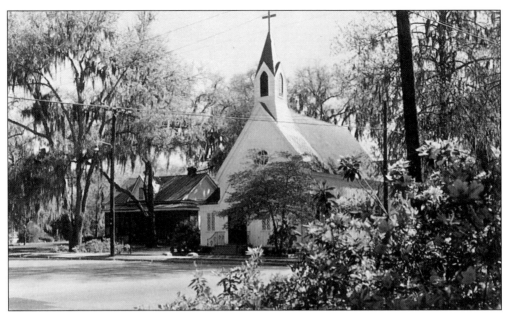

Before the Episcopal Walterboro Chapel was built in 1826 as a summer chapel, the congregation worshiped at Pon Pon Chapel of Ease near Jacksonborough. The first church structure built in Walterboro on this site was destroyed by the cyclone in 1879. The present building was completed in 1882. (Courtesy of Photo Arts, Winnsboro, South Carolina.)

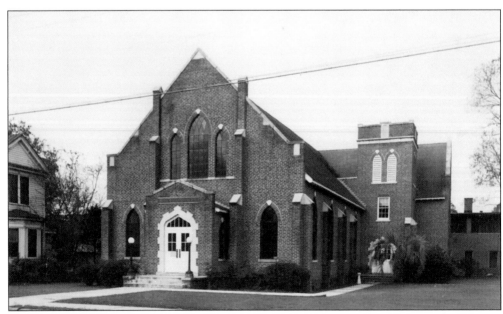

The Bethel United Methodist Church has owned this property since 1828. To finance a larger building, the church sold the space facing East Washington, and the new church, completed in 1929, was built facing Hampton Street. The parsonage on the left was torn down in 1955 and replaced with the education building. On the right is the building that People's Pharmacy occupied until they moved across the street and later became Hiott's Pharmacy.

The first chapel built by the Bethel Presbyterian congregation was completed in 1822 but replaced with a larger building in 1860. The church was destroyed by the cyclone in 1879. The new building was completed in 1880 but destroyed by fire in 1966. The present church, which is the fourth sanctuary on this site, is made of brick and was built in 1969.

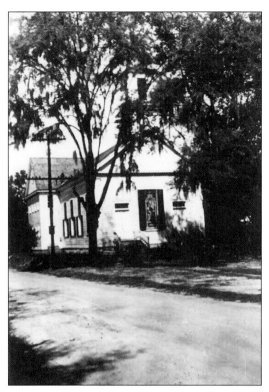

The congregation of the First Baptist Church moved from the Neyle Street building in 1954. This church burned in December 1963 and was rebuilt by 1968. They bought the Coca-Cola property across the street in 1982 and turned it into a parking lot. At the Bethel United Methodist Church in the background, they enclosed the steeple and installed stained-glass windows in 1973.

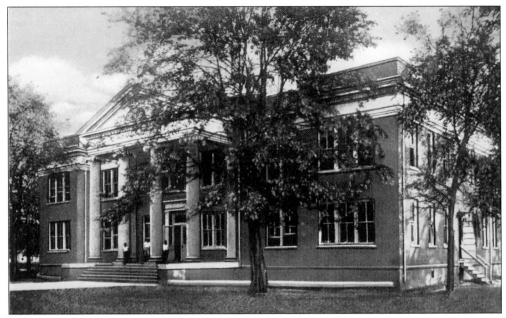

The Walterboro Graded School replaced the Walterboro Academy in 1911. The Academy building was moved down Hampton Street across from the high school. Later the name was changed to Walterboro Grammar School. The building faced Hampton Street and was the first school in the county to be built of brick.

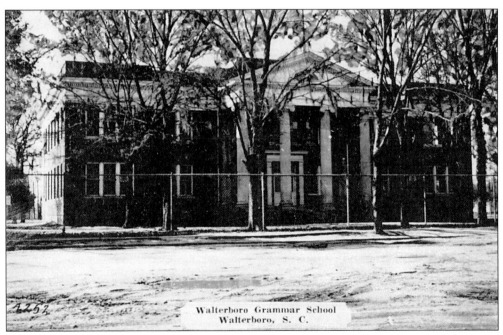

Walterboro Grammar School
Walterboro, S. C.

This building was torn down in 1939 and a larger school was built on the same site. The new school building still faced Hampton Street and had no columns; they moved the auditorium from the back of the school to the Hampton Street side. In the late 1950s the name was changed to Hampton Street Elementary School.

This property was originally owned by Mary Bellinger Glover, but when her house burned down, she moved to the lot where the First Baptist Church is today. The City bought the property and built Walterboro High School (WHS) on Hampton Street between Strickland and Carter. WHS served its students and faculty from 1924 to 1982, when a larger, more modern high school was built.

In 1985, the University of South Carolina purchased the property and established USC–Salkehatchie at Walterboro. As a part of the University system, Walterboro is described as a "University with a small college atmosphere" offering day and night classes in a variety of subjects. The original building was placed on the National Register of Historic Places in 1993.

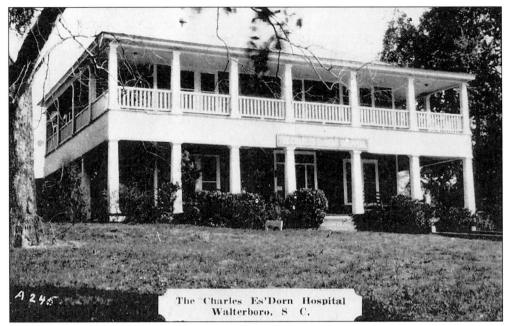

The Charles Es'Dorn Hospital
Walterboro, S C.

The EsDorn Hospital on Webb Street was next door to the EsDorn home, which housed the nursing students for many years. After Dr. Charles EsDorn's death, Mrs. Clara EsDorn renamed the hospital after her husband. Besides the excellent training school for nurses, the hospital had 35 beds, X-ray facilities, an operating room, and a laboratory. Their motto was "A community enterprise for community service." The building was destroyed by fire in 1992.

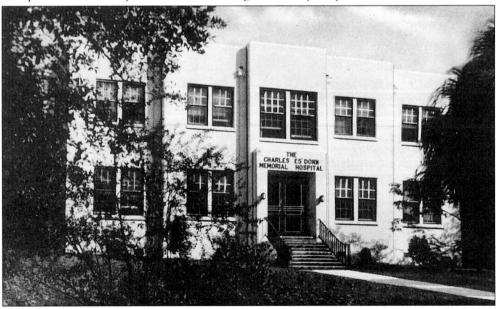

Three

CRUISIN' THE MAIN

Almost everyone who grew up in a small town has "cruised main street" to find out what was happening. The tourist trade of the 1920s through the 1950s created a lot of activity in downtown Walterboro. People would line up for almost a block to eat at the Lafayette Grill. If you were in the mood for a treat, you visited the Lollypop Trolley to get an ice cream cone.

Everyone in the county came to Walterboro to do their shopping. Depending on your taste in style, you could shop at Slotchiver's Department Store, Novit-Siegel Department Store, Mrs. Levy's, M. Warshaw, Simm's Toggery, the Brick Store (actually the Colleton Mercantile Company), Terry & Shaffer Department Store, Novit's Fashion Shoppe, Harry's Men's Shop, or Mademoiselle's. You could check out the new furniture at Easterlin Furniture Company or Hamilton's Coastal Furniture Company. Perhaps you needed something from a drugstore. There were eight of them on Washington Street. Today, Hiott's Pharmacy (which bought Peoples Pharmacy in 1965) is the only drugstore on Washington Street. From department and appliance stores to flower shops, from barber and beauty shops to snack bars, just about anything could be found on either side of the four blocks on main street.

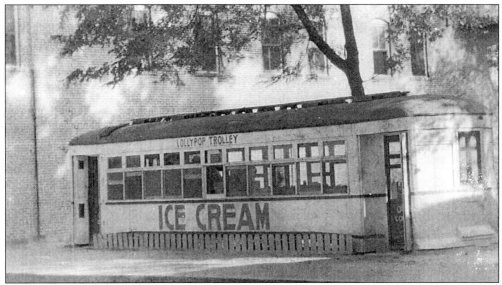

Lollypop Trolley, between the Brick Store and the Masonic Building/Post Office (later Novit-Siegel's Department Store), was opened in 1932 by Mr. and Mrs. Frank Starr, who was mayor of Walterboro. Eventually, the Trolley and the Brick Store were torn down to make way for a city parking lot.

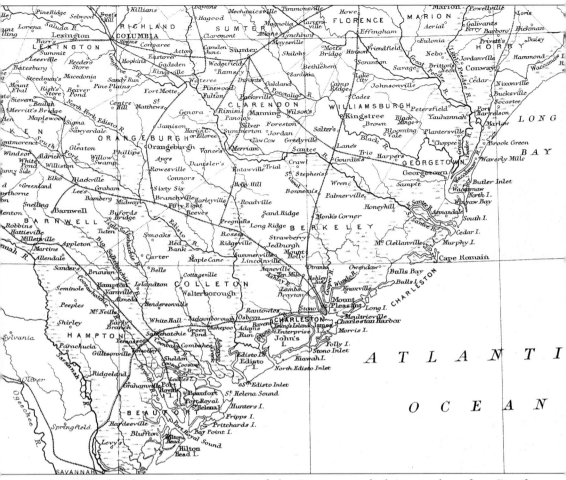

By 1880 the three original counties of the Lowcountry had increased to five: Beaufort, Berkeley, Charleston, Colleton, and Hampton. Notice that the north boundary for Colleton is along the same line as I-26 to the Stono River. Today, there are an additional two counties: Jasper and Dorchester. Dorchester County was created almost entirely from land that once was in Colleton County.

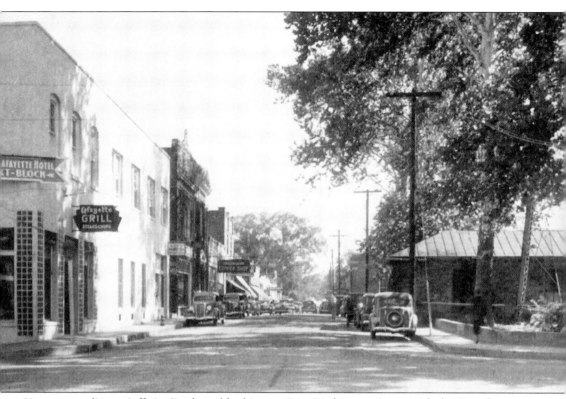

You are standing at Jefferies Boulevard looking up East Washington Street with the Courthouse square on the right and the Lafayette Grill on the left. This well-known restaurant was started in 1935 by Arthur Bauer and Albert Novit. The *Press and Standard* building, next door to the Lafayette Grill, has occupied the site since 1891. The present building was built about 1920. Walterboro has had a newspaper since 1877, but in 1890 the *Colleton Press* combined with the *Colleton Standard* and the *Press and Standard* was born. On the right one can view the tower grid for the water tower.

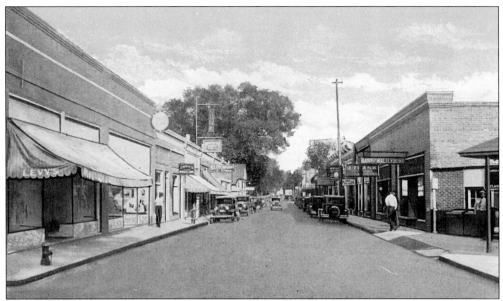

Now we are standing at Walter Street looking up East Washington Street. On the right is a filling station next to the Bank of Walterboro and J. Frank's. On the left is Mrs. Levy's dress shop that in 1913 was next to Terry & Shaffer Department Store. Mrs. Levy advertised as the "Only exclusive Ladies store in Colleton County" specializing in silk dresses and underwear. Notice the cars going in both directions.

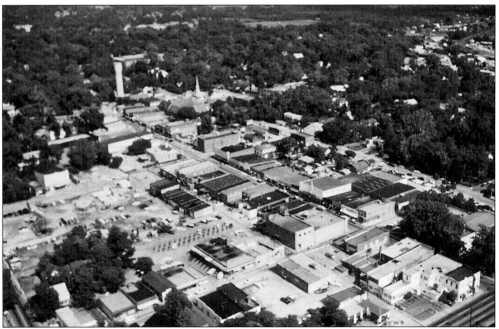

This view card of Walterboro shows the downtown area. The water tower is visible in the upper left corner. In the lower right is Jefferies Boulevard with the Lafayette Grill and the Courthouse square. Other businesses we have identified include the following: the post office, First Baptist Church, Lollypop Trolley, the Brick Store, City Hall, Walterboro Motor Sales, and Cook Theater. A Walterboro native might find more.

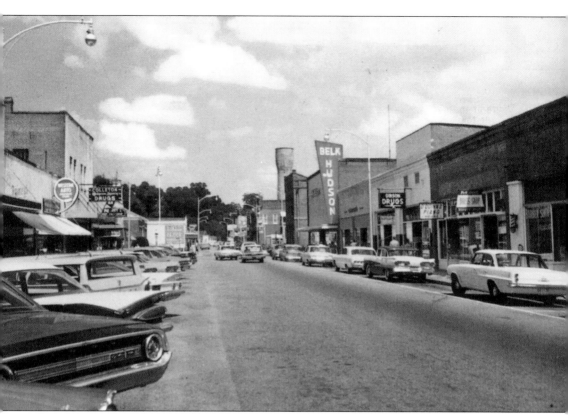

One can see the water tower in the background. It was completed in 1915 and has a 100,000-gallon capacity. The lower level was originally built as a jail, but it was so damp that prisoners were never detained there. In the late 1940s there were eight druggists on Washington Street: Colleton Drugs (Walgreen Agency), Gibson Kemp Drug Co., Heaton's Drug Store, Ackerman-Beach Drug Store, Kleins Drugs, Padgett's Pharmacy, Peoples Pharmacy, and Walterboro Drug Co. (the Rexall Store). On the left, notice the Western Auto Store, owned by Leon Gelson, next to Easterlin Furniture Co. Beyond Gibson Drugs on the right, one can see Thompson's 5¢ to $1 Store, Belk Hudson, and the Brick Store.

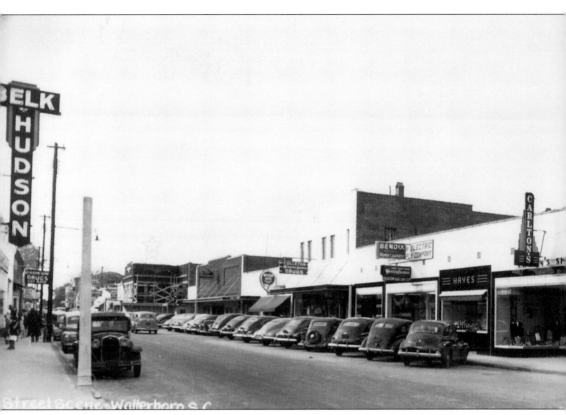

This real photo postcard is looking down Washington Street from Lucas Street. Notice the two-way traffic! Next to Belk Hudson, which moved to a larger store at Ivanhoe Shopping Center in August 1973, is Thompson's 5¢ to $1 store. This store still looks like an old-time variety store with items you wouldn't find anywhere else and is closed on Wednesday afternoons. On the right side, Hayes has moved up the street, but is still owned by the Harris family. Mortie Cohen owned Walgreen's Colleton Drugs, and Leon Gelson owned and operated the Western Auto Store. Next to Western Auto is Easterlin's Furniture store owned by W.C. Easterlin.

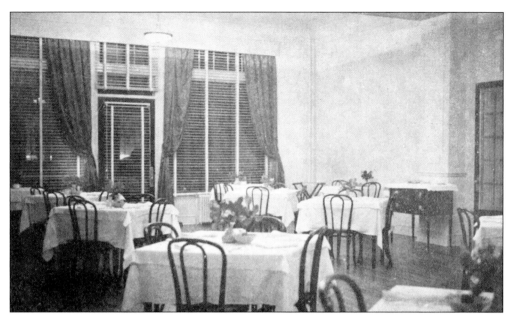

The first floor of Hotel Hayne, which was named for the American Revolution martyr Col. Isaac Hayne, included the lobby, this very nice coffee shop, a drugstore, and the Western Union office. It was on the corner of Jefferies Boulevard and Washington Street across from the Courthouse.

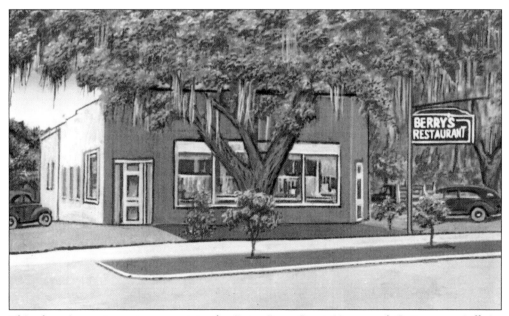

This charming restaurant was next to the Betsy Ross Guest House and Cottages on Jefferies Boulevard where Carn Street deadends. It was owned by Lucas C. Berry. It now houses Chapter I Educational Services.

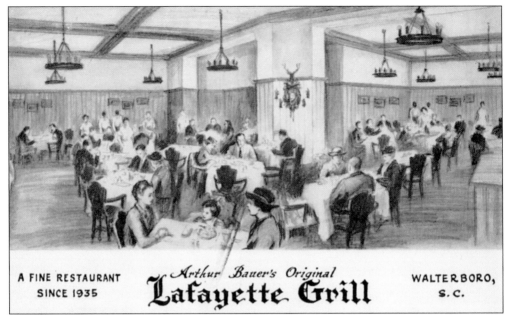

A FINE RESTAURANT
SINCE 1935

Arthur Bauer's Original
Lafayette Grill

WALTERBORO,
S.C.

At the corner of Washington and Jefferies, the Lafayette Grill was one of the best-known restaurants on the Lafayette Highway. One of their slogans was "A first class restaurant in the New York Manner." Just like the Lafayette Hotel right down the block on Jefferies, Arthur Bauer knew how to promote his product. He had many different postcards including the ones you find here.

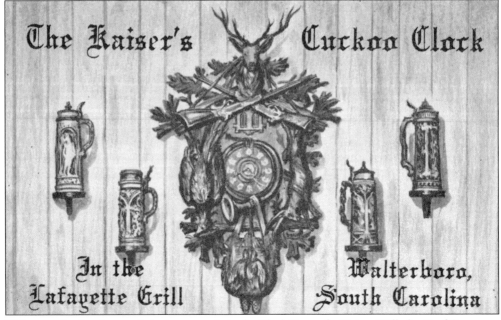

The Kaiser's Cuckoo Clock

In the
Lafayette Grill

Walterboro,
South Carolina

This attractive hand-carved clock was made in the Black Forest for Kaiser Wilhelm II of Germany. The clock is supposed to have hung at the Kaiser's favorite shooting domain or lodge in East Prussia. It was sold at auction with other royal items after World War I and brought to this country in 1923 to eventually hang on the wall of the Lafayette Grill.

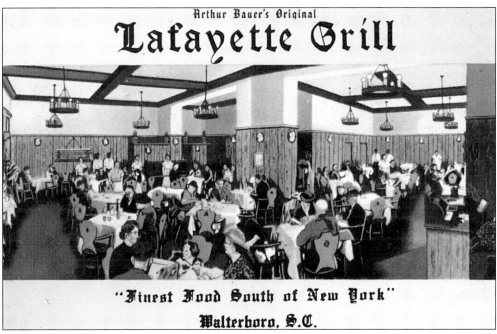

Arthur Bauer's Original

Lafayette Grill

"Finest Food South of New York"

Walterboro, S.C.

This postcard shows inside the restaurant before the Kaiser's clock was added. You could be entertained by "Polly" the parrot while waiting for a table, and the Grill was even recommended by *Duncan Hines Gourmet Magazine.* They also had another Lafayette Grill in Brunswick, Georgia.

WARNING!

FISHING POX

- - - Very Cantagious To Adult Males - - -

SYMPTOMS—Continual complaint as to need for fresh air, sunshine and relaxation. Patient has blan expression, sometimes deaf to wife and kids. Has no taste for work of any kind. Frequent checkin of tackle catalogues, Hangs out in Sporting Goods Stores longer than usual. Secret night phon calls to fishing pals. Mumbles to self. Lies to everyone.

— NO KNOWN CURE —

TREATMENT—Medication is useless. Disease is not fatal. Victim should go fishing as often as possibl

Arthur Bauer's

LAFAYETTE GRILL

A FINE RESTAURANT SINCE 1935

Walterboro, South Carolina

This is a comic or humorous sayings card, but is rare because it also serves as an advertising card for the Lafayette Grill. Actually, it is very appropriate for an area where fishing is one of the most popular recreational activities. Today the facility is used as the law offices of McLeod Fraser & Cone.

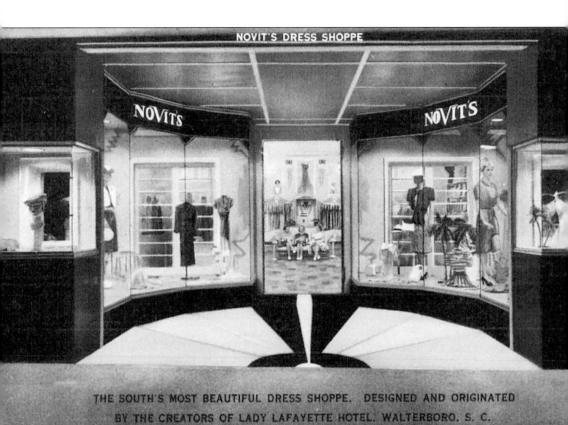

NOVIT'S DRESS SHOPPE

THE SOUTH'S MOST BEAUTIFUL DRESS SHOPPE. DESIGNED AND ORIGINATED
BY THE CREATORS OF LADY LAFAYETTE HOTEL. WALTERBORO. S. C.

This exclusive ladies apparel shop was established by Albert and Bessie Novit. Bessie managed the dress shop and Albert ran their other businesses (many with Arthur Bauer) including the following: the Albert Novit Company, Inc., Lafayette Grill, the Lady Lafayette Hotel, Novit's Department Store, Alart Farms, Hampton Heights Sub-Division, Forest Hills Development Company, and Radio Station WALD. The design of this postcard is uniquely done in the Art Deco style, which reflects the design and decor of the store.

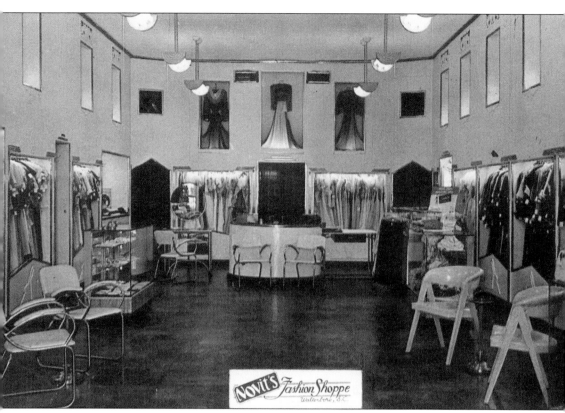

Here is another Art Deco card showing the inside of Novit's Dress Shoppe. By 1928 they also had Novit's Shoe Store next door (owned and operated by Sam and Frieda Novit) and had extended into men's clothing by adding the building behind the store. The business was continued by Sam and Leona Novit Siegel, the Novit's daughter. They moved the department store to the old Masonic building and renamed it Novit-Siegel's Department Store. The shoe and dress shop stayed in the corner stores at Washington and Water Street until 1994. Today Sam Siegel continues to run the other company businesses from his office in the old dress shop.

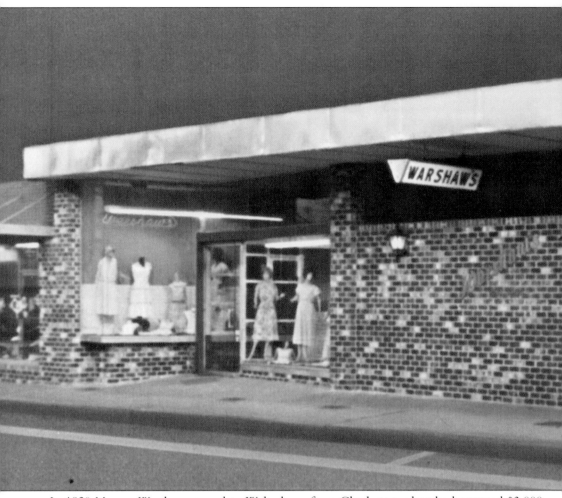

In 1920 Murray Warshaw moved to Walterboro from Charleston when he borrowed $3,000 from Albert Wichman at the Farmers & Merchants Bank. M. Warshaw's store began as a drygoods store. He changed the name to Warshaw's and after World War II, when his son, Bernard, returned from overseas, they expanded the store to include the two stores next to the original shop. It was now called Warshaw and Son. It was switched to Warshaw's Department

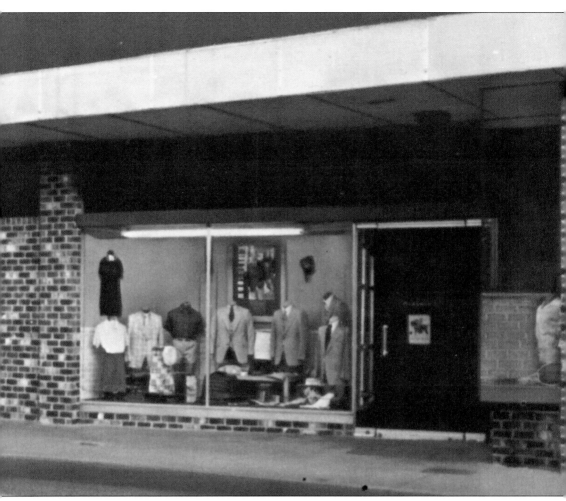

Store, but after his father passed away, Bernard Warshaw replaced the name with Warshaw's of Walterboro. The women's store is now closed and Chuck Bailey is the owner/manager of the men's store, but Warshaw's "Clothes of Quality" still boasts the slogan, "A ladies best accessory is a well-dressed man."

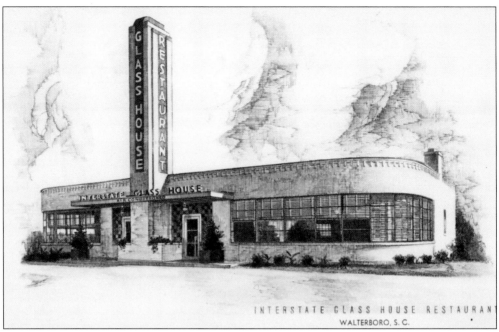

The Interstate Glass House Restaurant on Jefferies Boulevard opened in January 1940. It was part of a chain of restaurants, started in Chicago, that were usually combined with bus stations. Greyhound Bus Lines moved behind the Glass House. The bus station has been long gone, and the building was demolished. An Exxon station built on the property has recently been remodeled into a restaurant that carries the name of the "Glass House."

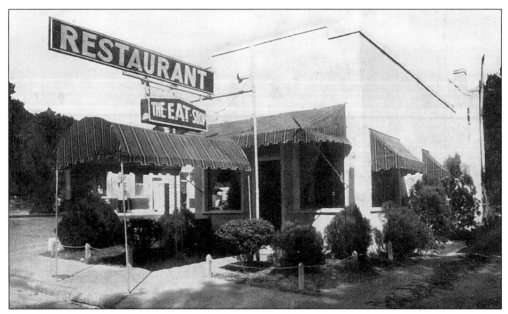

On Jefferies Boulevard, Mr. and Mrs. Clifton O. Crosby, who operated the Mayflower Inn and the Magnolia Inn, opened a restaurant next to Dinky Smith's Esso Station. The Eat Shop was popular with the locals as well because the food was good and the service fast. For many years the building has served as an attorney's office.

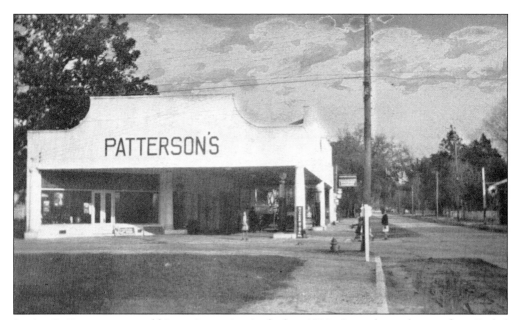

Lucien B. Patterson opened his service station in the late 1920s. It was located across from Bethel United Methodist Church on the corner of Hampton and Railroad. A 1928 *Press and Standard* ad stated, "Our repair charges are small and our guaranteed work is unqualified. Fill up Saturday with gas and oil as we will be closed Sunday."

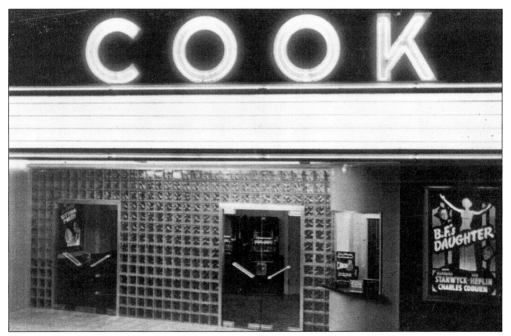

H.B. Cook bought the old New Era Theatre on Railroad Avenue and opened the Ritz Theatre. In the late 1930s he moved the Ritz to Washington Street. Mrs. Cook and her son, Henry Belk Cook, built the Cook Theater on Lucas Street in 1947, after Mr. Cook died, and managed the business for many years. The building was torn down for the back entrance to the new post office.

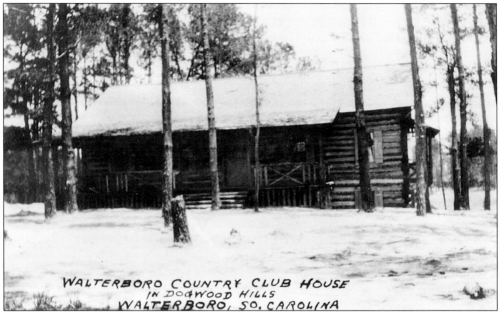

WALTERBORO COUNTRY CLUB HOUSE
IN DOGWOOD HILLS
WALTERBORO, SO. CAROLINA

The Walterboro Country Club on 17A toward Hendersonville was made of cypress logs. It was another WPA program started in 1935. Over the years it has been expanded and remodeled with rooms on one end and in the back, but it still maintains the original cypress log facade. The nine-hole golf course, the pool, and the Pro Shop are still part of the property. Today it is called the Dogwood Hills Country Club.

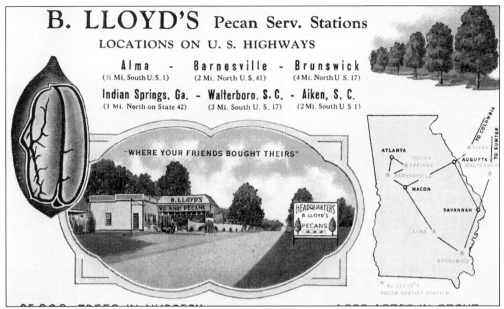

B. Lloyd's was a chain of service stations in Georgia and South Carolina that used the need for gasoline as a sure way to get people to stop and purchase pecans at the same time. You could buy them shelled or unshelled and they would mail pecans for you anywhere in the United States.

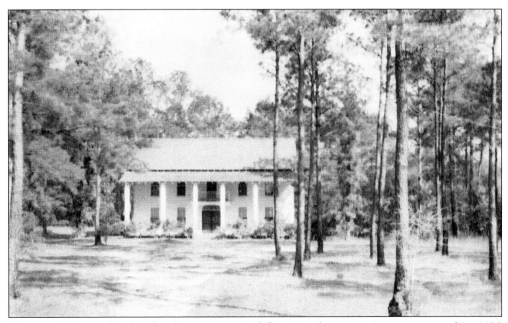

This Greek Revival style of architecture, typical for a Southern mansion, was erected in 1932 specifically for American Legion Post 93 of Walterboro. Sixty-six years later, it is still serving the same purpose for which it was built.

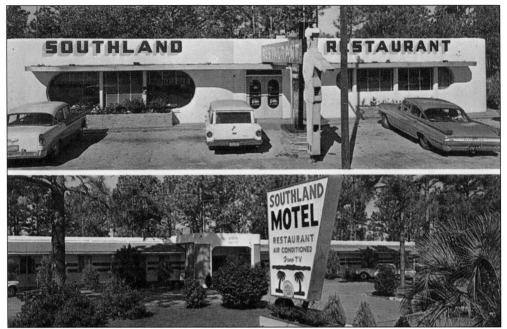

Southland Motel and Restaurant on Hwy 15 was originally owned by Ray Ball, but since 1949 it has been owned and operated by Ed and Mae Harriott with their son "Nicky." The motel has been changed into apartments, but the restaurant remains one of the popular local spots. They are best known for their spaghetti and the buffet. All their desserts are still homemade. (Courtesy of Photo Arts, Winnsboro, South Carolina.)

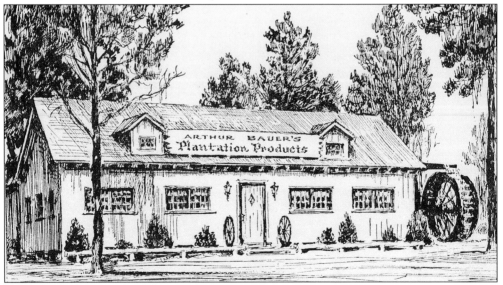

Another of Arthur Bauer's business establishments, this store specialized in products that were made and used on the area plantations including the following: homemade preserves, pickled artichokes, pecan pralines and other pecan products, artichoke relish, and watermelon rinds. They also sold gifts, antiques, and mammy dolls. They would mail anywhere in the United States. The property is now the entrance to Lafayette Acres at the end of the four lanes on Highway 15-North.

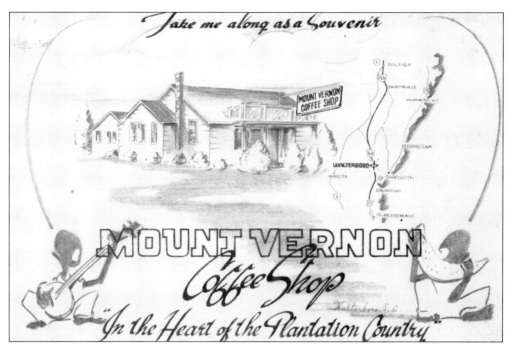

The Mount Vernon Coffee Shop was built on Hwy 15 next door to the Mount Vernon Tourist Court. It was operated by Mrs. Shelton J. Jones. Today the property is owned by the North Walterboro Baptist Church. They recently removed the coffee shop building from the area.

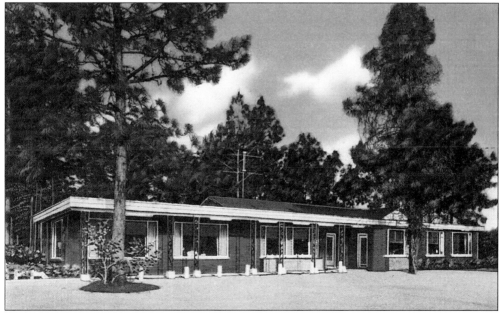

The Pine Crest Restaurant was on Hwy 15 next to Traveler's Motor Court. Built in 1943, it was owned and operated by Mr. and Mrs. J.A. Wooten. Pine Crest was a favorite with the local populace as well as the tourists because of Mrs. Wooten's pecan pies and batter-dipped fried chicken. The building was destroyed by fire, and it remains a vacant lot today.

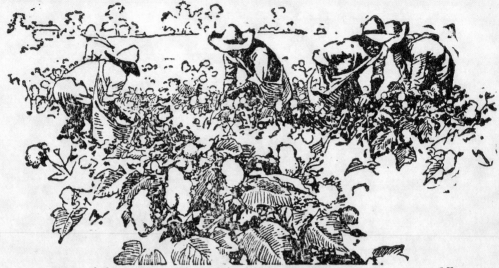

Regards from

ALART FARMS RESTAURANT

"Food as You Like it"

Two and three quarter miles North of WALTERBORO, S. C., on Route 15

Albert Novit and Arthur Bauer were business partners in a number of establishments around Walterboro. Here they combined not only a trailer park with a restaurant, but their names "Al" and "Art" to come up with the name "Alart Farms." They advertised as being in the "Heart of the Plantation Country" where you could "Get steaks with no mistakes" and "Food as you like it." It was managed by Cora and Gus Demetrion. This card is not only valuable as an advertising card but also as a black collectible.

Four

OUT AND ABOUT TOWN

A town is made up of people, where they live and work. There are many lovely older homes within the city dating to the 1800s. Tour guide maps are available from the Chamber of Commerce that include over 35 homes. The Colleton County Historical and Preservation Society sponsors tours of these homes, including plantations in the county, as a fund-raising activity.

We wanted to include some real photo postcards of people who lived in Colleton County in the 1910s, 1920s, and 1930s. The *Press and Standard* newspaper published an article about real photo postcards using a number of our examples. Suddenly, complete strangers called or wrote with real photo cards they were willing to share and we are pleased to include ten of them for your perusal.

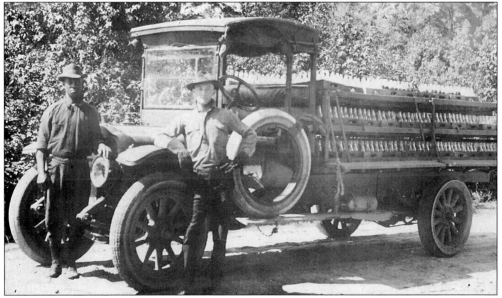

Here is a very rare card. In 1922, T.J. McDaniel organized the Coca-Cola Bottling Company in Walterboro. They started out with two mules and a horse, but very soon they were using trucks. Everyone was so proud they took photos. The young driver here just happens to be Julius E. Breland (right). Driving and delivering Coca-Cola was one of his first jobs as a young man. Later with his wife, Reba, they raised two children, Walker and Irene, and ran Breland's Guest House on Jefferies Boulevard. In the 1940s he served on the town council. We have been unable to identify the man standing with Mr. Breland.

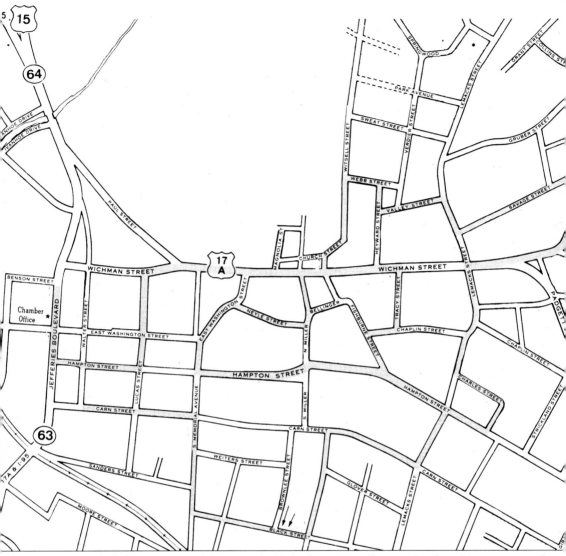

You won't find too many straight streets in Walterboro. As trails were developed into streets and roads, they followed the same route going around a man's property instead of through it. It has never been changed.

What has changed are the street names. Here are the ones we know about. Starting on the left of the grid: Jefferies Boulevard was Bridge Street; Walter Street was Water Street; Wichman Street was Walter Street; East Washington Street was Main Street; Memorial Avenue was Railroad Avenue; the part of Memorial Avenue between East Washington Street and Wichman Street was Lowndes Street; Magnolia Street was Market Street; Neyle Street was New Street; Miller Street was Academy; Fishburne Street was Cross Street; Tracy Street was Driffle Lane; the part of Charles Street that ends at Hampton was Carter Street; and Hampton has been Jackson, College, and Dunwoody Street.

When W. Marshall Sauls (b. 1881) married Hattie Trowell Sauls (b. 1883) in 1905, they settled on a farm in Mashawville. Marshall was a farmer and Hattie was a licensed LPN. They had three children, Miles Huger (b. 1907), Ida Mae (b. 1911), and Norma Marie (b. 1914). Ida Mae graduated from Walterboro High School in 1929 and worked at Novit's Dress Shoppe in the 1930s. She became a licensed LPN, married M. Bays Hiott, and still lives in Mashawville.

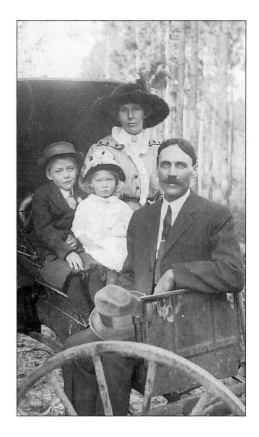

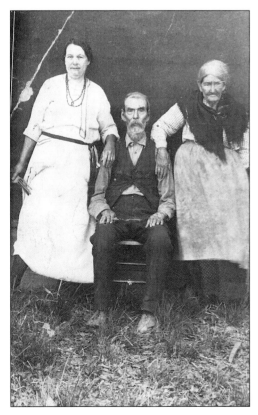

Jackson C. Cook (b. 1842) is shown with his wife, Caroline Padgett Cook (b. 1854), and a daughter, Sarah. Mr. Cook served in the South Carolina Infantry, Company E, 11th Regiment during the Civil War and was captured at Petersburg, Virginia, in May 1864. Cook was transferred to a POW camp in New York state and released in July 1865. He died in 1927 and is buried at Carter's Ford Church in Lodge. His great-granddaughter is Raye Cook Murdaugh.

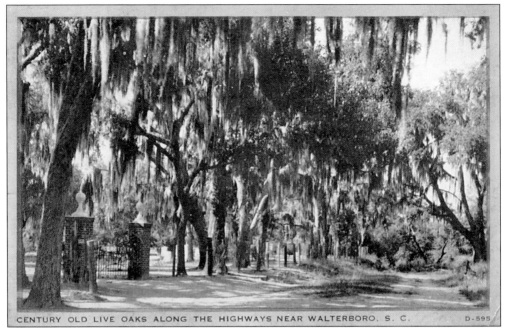

CENTURY OLD LIVE OAKS ALONG THE HIGHWAYS NEAR WALTERBORO, S. C. D-595

Originally, these grounds were used as a military muster field, a dueling ground, and a race track. In 1874, when Ruth Miller Harley Beach donated 5 acres of land, a Board of Trustees was organized to develop Live Oak Cemetery. The Trustees included J.W. Burbidge, president; C.G. Henderson, secretary; and A. Wichman, treasurer. The plots originally sold for $10 each. The side gates today were the main gates as travelers passed the cemetery, went down through the swamp, and on to Savannah.

This view is from Lemacks Street looking toward Hampton Street Elementary School. Hampton Street was named for General Wade Hampton, a Confederate calvary leader who later became governor of South Carolina. Many historic homes line both sides of the street.

58

Raymond H. Beach poses here in his World War I infantry uniform. After the war, Mr. Beach returned to Walterboro, went to work for the post office, and served as a Colleton County rural mail carrier for 43 years. He and his wife, Ruth Breland Beach, raised four children, Elizabeth, Ladson, Vernon, and Jack.

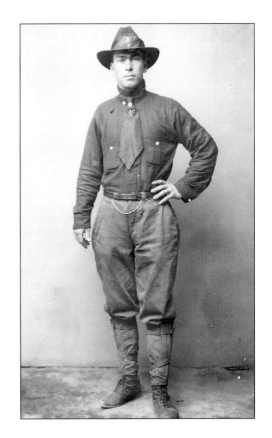

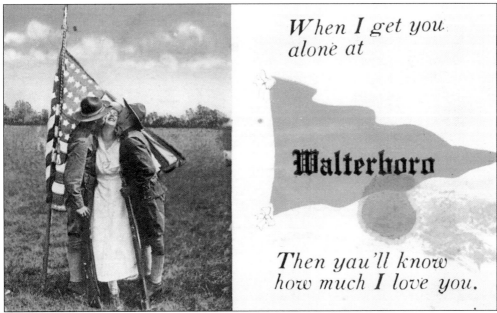

When I get you alone at

Walterboro

Then yau'll know how much I love you.

Banner cards, with different names stamped inside the banner, were used mostly for cities, small towns, schools, and colleges. This card is unusual in that it shows two uniformed servicemen kissing the cheeks of a uniformed nurse from World War I.

This real photo postcard of Budd George Price III was taken about 1928 when he was in the ninth grade at Walterboro High School. He married Elizabeth Starr. After serving in World War II, he founded Colleton Tile & Concrete Co. He served as postmaster of Walterboro from 1951 to 1977 and was active in civic and church affairs. He has a daughter, June Price Breland, and two sons, Budd IV and Frank.

This delightful little girl is Virginia Riddle (b. 1908) with her "Dollbaby" and brother Sam. She had three more brothers, Ned, Billy, and Fletcher. Their parents were Samuel Marvin Riddle and Edna Jones Riddle. Born in Walterboro, Virginia went on to become a teacher in the Walterboro school system and married Marion Walter Sams. They had two children, Edna Sams Lewis and Marion Walter Sams Jr.

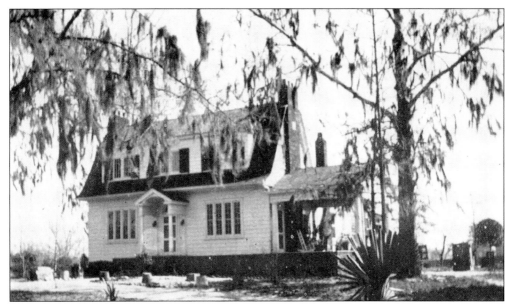

This house on Wichman Street referred to as Rose Hill was built by E.T.H. Shaffer (1880–1943) in 1928. His family originally lived in the house that became the Palmetto Inn. Born in Walterboro, Mr. Shaffer graduated from the College of Charleston in 1900. He was co-owner of the Terry & Shaffer Department Store on Main Street and was also an accomplished author. His book *Carolina Gardens*, first published in 1937, has been reprinted twice.

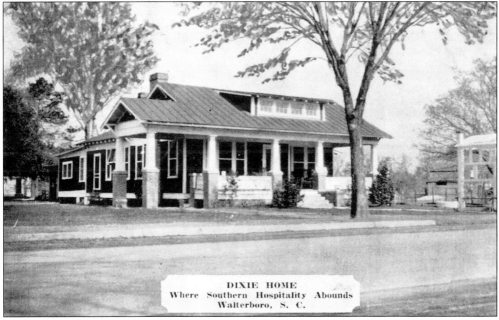

DIXIE HOME
Where Southern Hospitality Abounds
Walterboro, S. C.

This was Mrs. Griffin's Boarding House on Jefferies Boulevard, down from Betsy Ross Guest House. It was beyond the railroad tracks and across the street from the Speedy Express Station. She served meals to her roomers and local patrons. The Huffines Co. was located here for a number of years before they moved into their new offices on Wichman Street. Most recently the building served as an office for an optometrist.

A political campaign postcard shows Peden Brown McLeod sitting on steps with his wife, Mary Waite McLeod. Mr. McLeod has served in both the State House of Representatives and the Senate. He has been awarded the Order of Palmetto, which is the highest award in the state. His father, Walton J. McLeod Jr., was a law partner of Senator R.M. Jefferies and served as the Walterboro city attorney for over 60 years.

Another political card is of W.D. "Bill" Workman Jr., his wife, Rhea Thomas Workman (from Walterboro), their daughter, Dee, and son, Billy. Billy was the mayor of Greenville for two terms. Mr. Workman was editor of the *Columbia Record*, the evening newspaper in Columbia. Dr. Workman taught at Columbia College and her mother, Ruth Thomas, taught at Walterboro High School and started the Future Teachers of America at WHS in 1935.

Sara Brabham Starr is shown with her daughter, Elizabeth, and newborn son, Patrick Harry. Mrs. Starr and her husband, Frank, moved to Walterboro from Olar, South Carolina, in 1921 to manage Walterboro Motor Sales. They opened the Lollipop Trolley on Washington Street in 1931. "Sally" became "grandmother" to many as she oversaw a playground in her large front yard on Black Street from the 1940s to the 1960s.

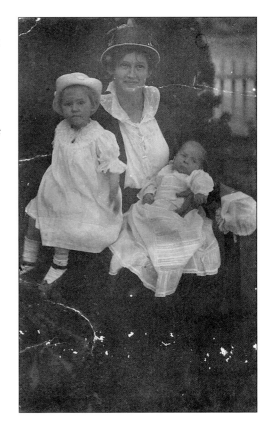

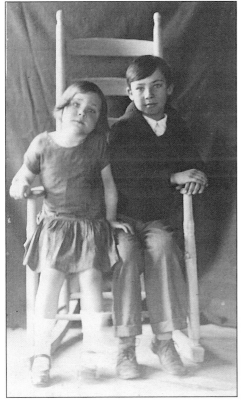

Here is a *c.* 1931 postcard of brother and sister, Wilma Nettles (b. 1924) and Frampton Nettles (b. 1921). They lived with their parents, Dowling and MaCara Jane Nettles, on a farm in the Snider's area. Later in life, Wilma married William "Bill" Jackson Cook and had four girls and one boy. One of her daughters is Raye Cook Murdaugh.

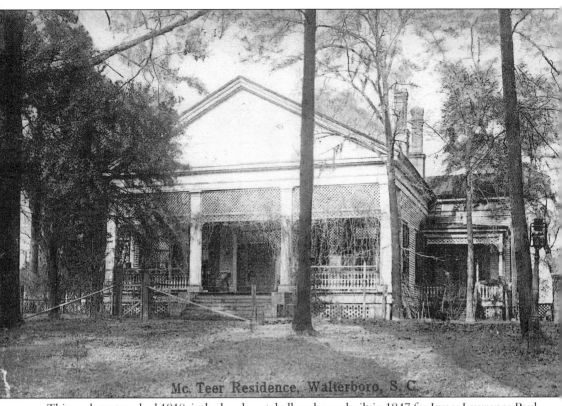

Mc. Teer Residence, Walterboro, S. C.

This card, postmarked 1910, is the lovely antebellum home built in 1847 for James Lawrence Paul. The ceilings are 15 feet high and the windows are 4 by 12 feet. The front door opens to a wide hall that extends to the back porch. In 1851 James sold all his property to his brother, Sampson Leith Paul, and moved to California. In 1890 Sampson Paul sold the house to the L.S. McTeer family. The McTeers had two daughters. Jenny McTeer's wedding to Albert Wichman was held in the house, and she lived there until her death. Her sister, Lucille McTeer, married Dr. John Klein. Today the Paul-McTeer house is the home of Mr. and Mrs. Carleton Burtt.

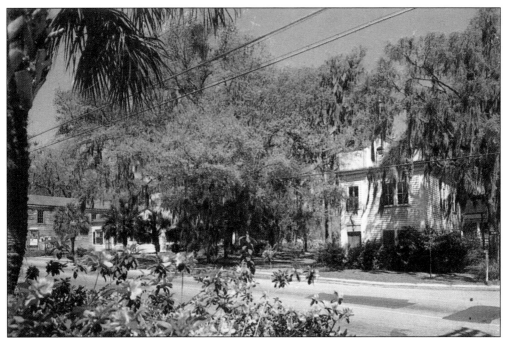

Through the moss-covered oak trees, one can see the Little Library building in the middle; the Ezra Miller building, later known as Drawdy's Grocery Store, on the left; and the Civic League building on the right. The Civic League building housed the Girl Scouts, the Red Cross, the Civic League, and the YMCA before it was demolished in 1960.

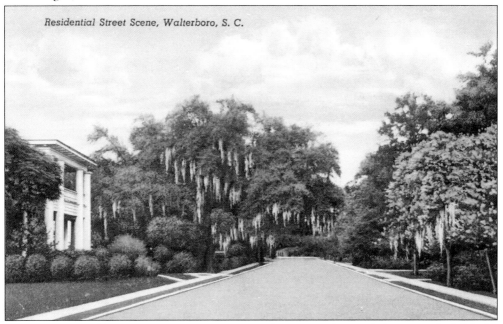

Residential Street Scene, Walterboro, S. C.

This scene is actually Hampton Street near Memorial Avenue. The stately home on the left is the Villa Mae Tourist Home. The Villa Mae was torn down, and today the Colleton County Rural Fire Department occupies the property. Across the street is Mrs. D.B. Black's house, which was also a Tourist Home for many years.

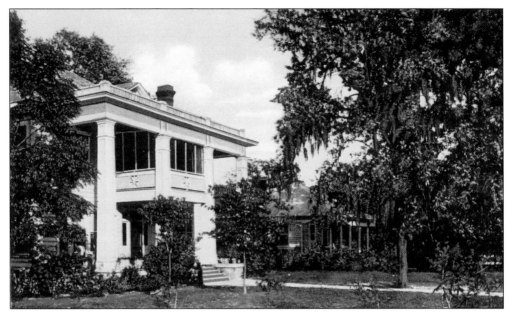

This stately home is at the corner of Lemacks and Hampton. It was built for Christopher Gasden Padgett, the president of the Bank of Walterboro. Today the house is owned by Lucas C. Padgett. Next door was the home of Budd George Price Jr. and Ethel Gruber Price. He served as the city engineer for many years. Today the home is owned by his grandson, Budd George Price IV.

Flowers and trees bloom year round in Walterboro. In spring, the yards are awash in a riot of color from the azalea bushes of white, pink, purple, and lavender, white and pink dogwood, wisteria, yellow jassamine, cherokee rose, tea olive, indica, and camellia. Later in the summer gardenia and crepe myrtle bloom as well as oleandars, hydrangea, and daylilies. Several garden clubs help maintain numerous areas of flowers in the town.

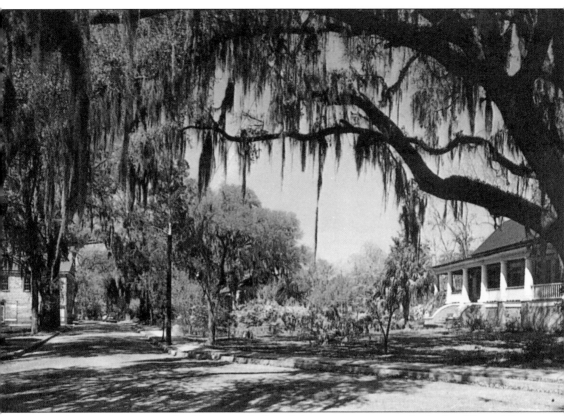

By standing on the corner of Fishburne and Church Streets, one can see the back of Drawdy's Store on the left and the Bedon-Lucas house on the right. Drawdy's Store was built in 1822 by Ezra Miller. A gas station and convenience store now occupy the space. N.Y. Perry built the house about 1820 and later sold it to Richard Bedon. Mr. Bedon gave the lot in front of the house to the Library Society in 1843 and then sold the house to Clarence Lucas. It remained in the Lucas family until it was purchased by the Colleton County Historical and Preservation Society in 1996. Major renovations are underway, without changing the design, to turn this wonderful old home into offices and meeting spaces for the Society and to create a place for cultural and social events for the community.

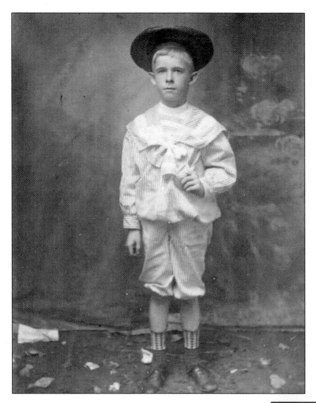

R. Ludlow Fraser III (1900–1991) was eight when he posed for this picture. His parents were Robert Ludlow Fraser Jr. and Sophia Henderson Fraser. He was born and died in the same house on Wichman Street. Mr. "Lud" married Eugenia Robertson from Edisto Island. They had three daughters, Helen, Charlotte, and Mary Ellen. He worked for the post office for 46 years and was the treasurer of Bethel Presbyterian Church for over 40 years.

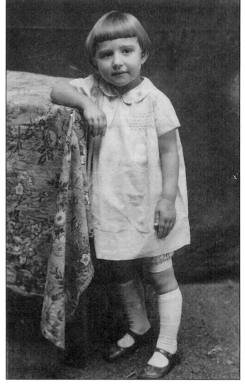

This beautiful little girl is the oldest of the Ilderton children, Mary Clair Ilderton Hacker. She was born in 1923, and this image was taken when she was about three years old. Mary was a lifelong resident of Colleton County and a longtime member of the Rehoboth Church. She died in 1972 and is buried in Ackerman Cemetery in Cottageville.

Five

CITY OF HOSPITALITY

About the turn of the 20th century, Northerners discovered something about the South that was taken for granted by Southerners. There were no snow blizzards or ice storms in the South during the winter months, and as transportation and the highway systems improved, they came by the thousands to vacation in the sunshine. If they were driving from New York, they needed places to rest and spend the night before reaching their destination in Florida. The same was true on the trip back home, and in South Carolina that spot was Walterboro. According to notes on the reverse side of these cards, this was the stop when they removed their heavy coats, found a wide choice of places to spend the night, and could get a good meal. The weather was usually so good that they could walk around town in the evenings, window shop in the stores, view the lovely old Southern style homes, and buy a treat before retiring for the night. Yes, they did run into showers, but the best part about rain is—you don't have to shovel it!

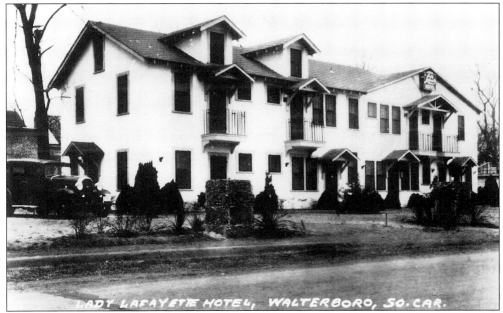

The Lady Lafayette Hotel opened in 1935 with eight bedrooms upstairs and six bedrooms downstairs. The baths were tiled, the floors carpeted, and there was a writing desk in each room. The hotel stood on the corner of Jefferies Boulevard and Wichman Street. Today a Burger King is on the property.

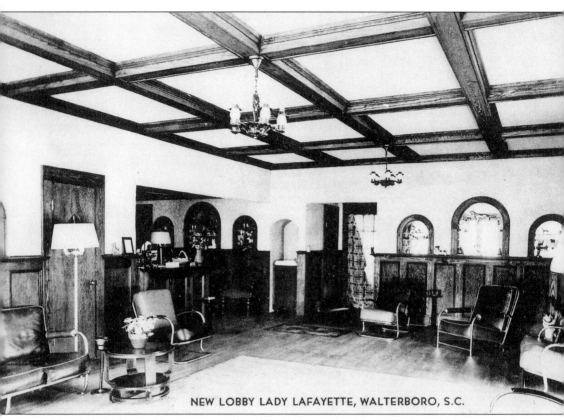

NEW LOBBY LADY LAFAYETTE, WALTERBORO, S.C.

The Lady Lafayette Hotel was an Albert Novit Enterprise. The lobby boasted "America's largest collection of miniature dog figurines under glass." Patrons would return to the hotel with another dog statue to add to the collection and some statues were even mailed. If you counted the full-size dog figures, the collection included over 5,000 different dogs. About 1939, a Universal short (usually around 15 minutes in length) titled "Stranger Than Fiction" was done about the dog collection and shown in movie theaters around the country. In fact, the Lady Lafayette was named after the Novit's Saint Bernard. You could also sit in front of the huge fireplace, which was big enough for full-sized logs, or rest comfortably in modernistic chairs that surrounded the lobby area.

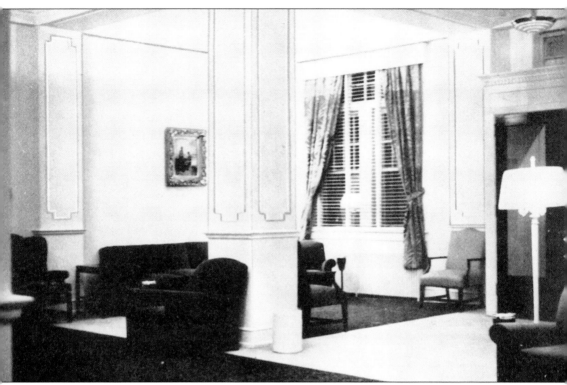

The Hotel Hayne was named for Col. Isaac Hayne, the Revolutionary War patriot from Colleton County. As seen by this lobby postcard, the decor was considered typical Southern or described as refined and elegant, but comfortable. This lobby was not so much a gathering place as it was a quiet room to read the paper, write a letter, or just relax with a good book. Their slogan was "Catering to a discriminating clientele." The hotel stood at the corner of Jefferies Boulevard and Washington Street across from the County Courthouse.

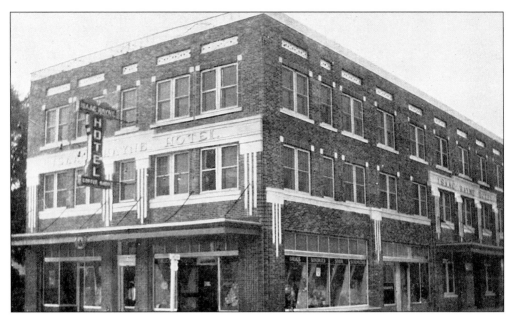

The Isaac Hayne Hotel was built in 1937. It had 3 floors, 50 rooms, 42 baths, telephone, ceiling fans, and also boasted one of the first elevators in the area. Each room was an outside room with a private bath and telephone service. It was originally owned by John E. Lindsay. Later it was managed by Frances and B.H. "Pie" Guy Jr. The hotel building remained empty for many years and was eventually destroyed by a fire. Today the space is occupied by the Blue Star Memorial marker and a civic parking lot.

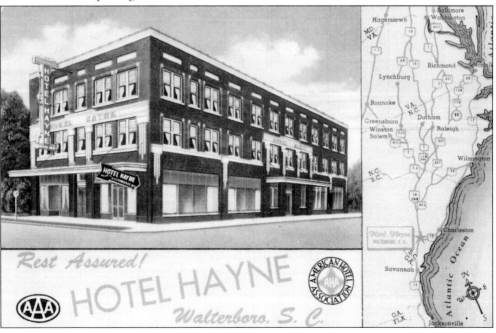

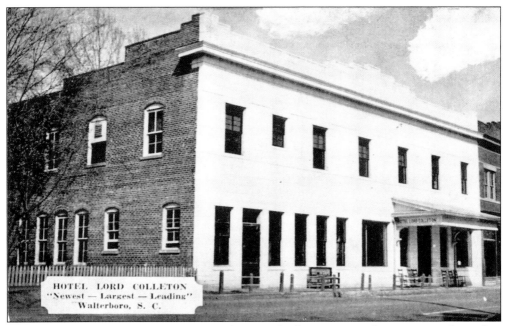

The Lord Colleton Hotel was first operated as Hotel Albert. In 1928 the name was changed to the Cooper-Reed Hotel by L.A. Reed. It had 40 rooms with hot and cold running water. Later it was changed to the Hotel Lord Colleton, which boasted ceiling fans in summer and a modern Crane heating system for winter. They even had auto storage in steam-heated garages.

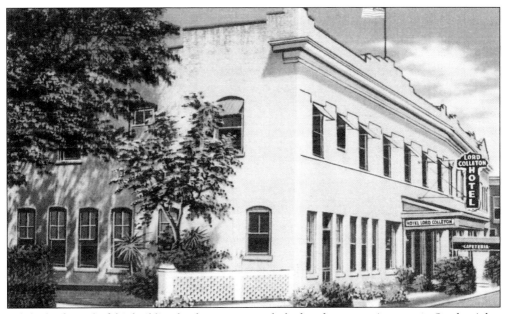

While the far end of this building has been renovated, the hotel part remains empty. On the right-hand side of the hotel, actually across Wichman Street, you can view part of the four stores that were there. They were replaced with a Winn-Dixie (before it moved to Robertson Boulevard). The building now houses the IGA grocery store.

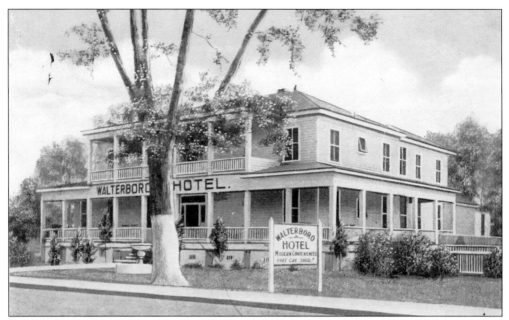

Originally the Ackerman-Turner Sanatorium in the 1920s, it became the Walterboro Hotel in the early 1930s. It was located on Jefferies Boulevard at Sanders Street. Their slogan was "Polite attention with a Homelike atmosphere." The hotel had verandas on both floors for patrons to sit in rocking chairs.

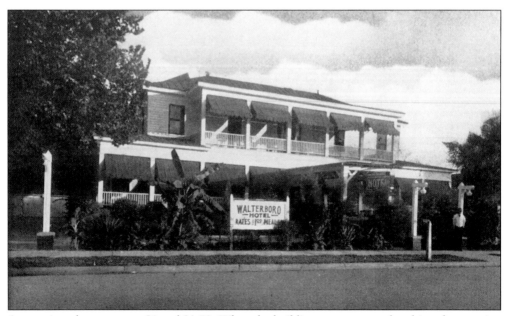

At one time the rates were $1 and $1.50. When the building was renovated, a drive-thru awning was built in front of the main entrance to protect guests in inclement weather. The hotel was torn down to build a Citgo gas station and convenience store.

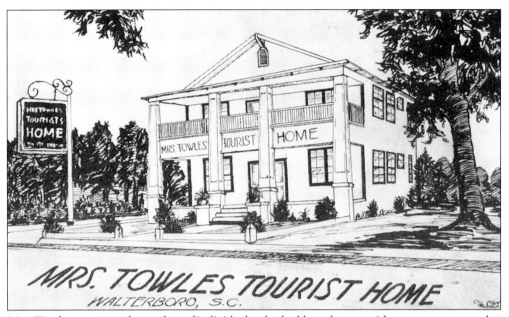

MRS. TOWLES TOURIST HOME
WALTERBORO, S.C.

Mrs. Towles was one of a number of individuals who had large homes with numerous rooms that they converted into tourist homes in the 1920s and 1930s. In 1939 Mr. and Mrs. C.O. Crosby, who had managed the Palmetto Inn before it burned down, bought Mrs. Towles house and changed the name to the Mayflower. They raised their children in the house while they took in tourists here and at the Magnolia Inn. The Crosbys also owned the Eat Shop. Their children loved it because they grew up eating in restaurants.

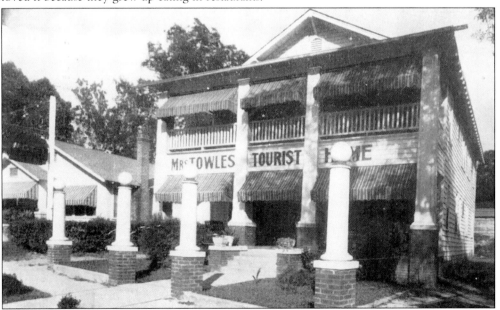

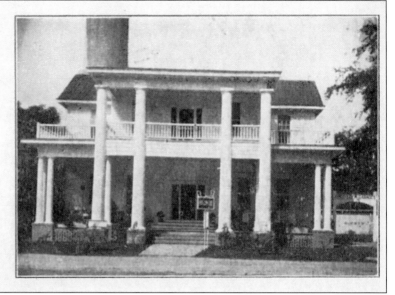

Villa Mae

The Home Of

Mrs. J. M. Lee
Walterboro, S. C.

Open to Tourists

FREE LOCK
GARAGES

CHICKEN
DINNER
Every Day

Located on U. S.
ROUTE 17
3½ Blocks From
Junction Point of
Route No. 30.

Here are two of the popular tourist homes in Walterboro. People could stay in a lovely house, get personalized attention, and some of them were also offered a meal. The Villa Mae, home of Mrs. J.M. Lee, and Mrs. David B. Black's home were across from each other on Hampton Street. Mrs. Black began taking in tourists in the early 1920s and continued until her death in the 1960s. One can view the water tower behind the Villa Mae. It is apparent from these cards that the ladies enjoyed some healthy competition.

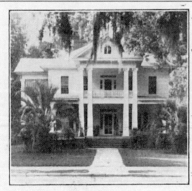

Where
Tourists
Feel
at
Home

Phone
4701

Private
Mailing
Card

Place
Stamp
Here

MRS. D. B. BLACK'S HOME
88 E. Hampton St. Walterboro, S. C.
Good Beds, Showers, Bath Tubs
Lavatory and Heat Register in Each Room
Iced Drinking Water—Lock Garages
ALL ROOMS COOLED AND HEATED
BY MODERN OIL-O-MATIC SYSTEM
Cool in Summer! -:- Warm in Winter!
Going south on U.S. 15, turn left at junction of
U.S. Highways 15 & 17. Only 3½ blocks
on U.S. Highway 17.

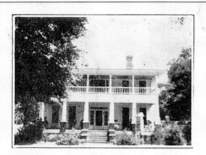

Mrs. W. H. Saunders

Member of the National Wayside
Homes and Federal Hi-way Homes
for Tourists.
91 E. Hampton Street.
Walterboro, South Carolina.
Turn at Standard Station on U. S.
15 (401) to U. S. 17—3½ Blocks.
HOT AND COLD RUNNING
WATER IN ALL ROOMS.
Free Lock Garages.

Mrs. W.H. Saunders opened her home, next to the Villa Mae on Hampton Street, to tourists, and down the street Edgar and Arline Jones did the same. Mr. Jones owned a CPA firm that was located over the *Press and Standard*. Notice that Mrs. Jones was the "hostess to overnight guests." Look carefully in the left-hand upper corner and you will see the water tower in the background. Today, Mr. and Mrs. Henry Hiott live in the Jones' home and the Saunders house is an apartment building.

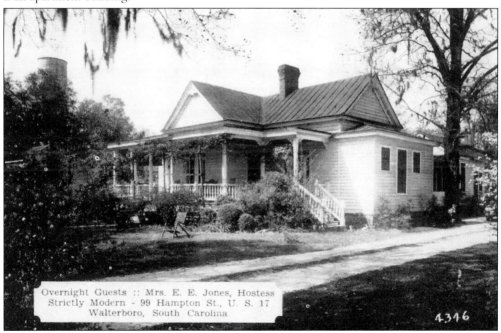

Overnight Guests :: Mrs. E. E. Jones, Hostess
Strictly Modern - 99 Hampton St., U. S. 17
Walterboro, South Carolina

4346

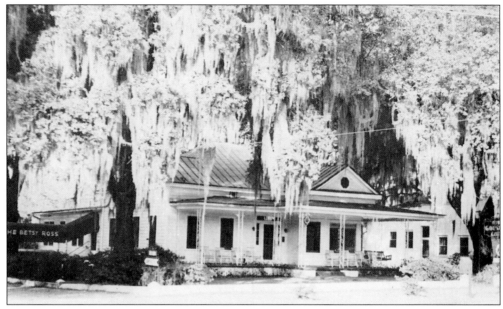

On Jefferies Boulevard, next to Berry's Restaurant and Berry's Tourist Court, was the Betsy Ross Guest Home and Cottages, owned by Mrs. John Hiers. The guesthouse had a wraparound porch, "year round air conditioning" and automatic heat. There were free parking spaces. Today the building is unoccupied.

S-544

What thoughts men have at times as these
When seeing magnificent, aged trees
Bowing their heads in humble thanks
Over the water's gracious banks.

GREETINGS FROM WALTERBORO, S. C.

© C. T. & CO.

Here are a series of "Generic" postcards. A publisher would take a number of scenes typical of an area and stamp town names at the bottom of the card. Most of these cards would say "Greetings From . . ." Some were used as advertising cards with the business stamped on the back. They might include a verse as this one does.

Here is a generic greeting card showing black laborers harvesting turpentine. There actually was a turpentine industry in Colleton County from the 1920s to the 1940s. There were, at least, six turpentine distributors in the county, including two in Stokes and one each in Walterboro, Canadys, Smoaks, and Ruffin.

GREETINGS FROM WALTERBORO. S. CAR.

Contrary to much local debate, this is not a scene from Walterboro, but a generic greeting card that was stamped by the publisher and distributed at the Walterboro Hotel (which has been stamped on the back).

The trees are etched in silver,
The waters flecked with gold.

All duty bows to beauty,
And night our cares enfold.

GREETINGS FROM WALTERBORO, S. C.

© C. T. & CO.

Another generic greetings with verse, this card was distributed at the Lady Lafayette. The message on the back says, "When in Walterboro, South Carolina, See Lady Lafayette."

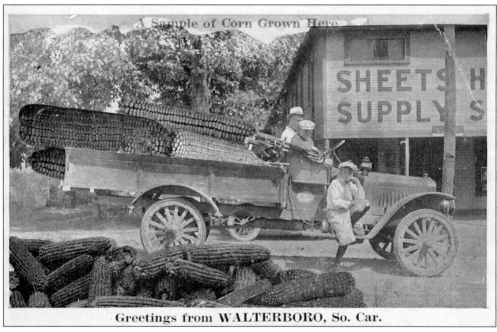

A Sample of Corn Grown Here

SHEETS H
SUPPLY S

Greetings from WALTERBORO, So. Car.

This is a generic exaggeration postcard. Notice that everything in the picture but the corn is of normal size. It was actually shrewd to use a card showing corn since it has been a major crop in the area for many years. There has never been a store in Walterboro that resembles this one.

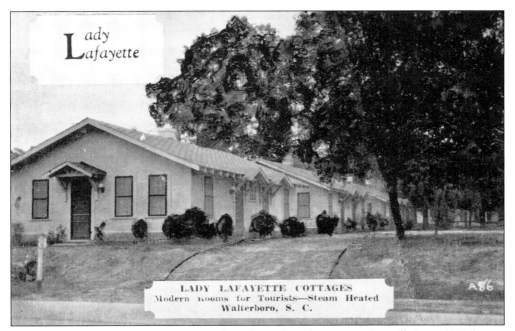

LADY LAFAYETTE COTTAGES
Modern Rooms for Tourists—Steam Heated
Walterboro, S. C.

The Lady Lafayette Cottages were across from the Lady Lafayette Hotel at Jefferies and Wichman. Between the Lady Lafayette Hotel, Lady Lafayette Cottages, and Annex, there were about 104 rooms available and usually filled to capacity seven nights a week. Today there is an Amoco Station where the cottages were situated.

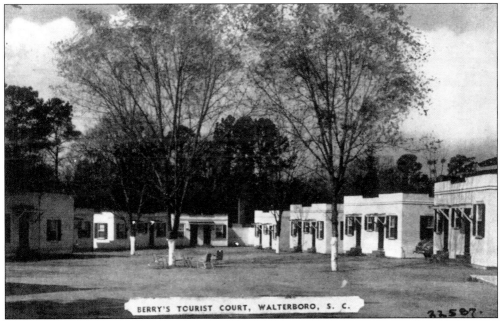

BERRY'S TOURIST COURT, WALTERBORO, S. C.

The owner of Berry's Tourist Court was H.L. Berry. It was centrally located on Jefferies Boulevard next to the Betsy Ross. They advertised Beauty Rest mattresses, steam heat, and showers. Their slogan was "Make this your home while at Walterboro." There are a few of the units still standing, but they have been empty for many years.

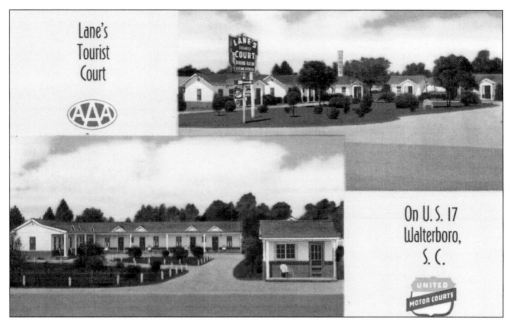

This tourist court was owned by Mr. and Mrs. O. Lane and managed by Jack Sanford. His daughter, Frances Sanford, taught at Walterboro Grammar School. There were 20 units with private tile baths and steam heat. Their slogan was "One of the South's finest." No longer a tourist court, the property is owned by Jackson Hughes, who uses the court's main building as his office and the units for storage.

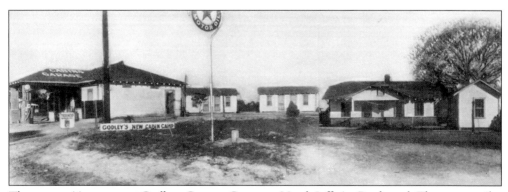

There were 11 cottages at Godleys Cottage Camp on North Jefferies Boulevard. There was trailer space available and a free locked garage. They advertised that some units had a private bath. The Godleys renovated the camp and renamed it El Rancho.

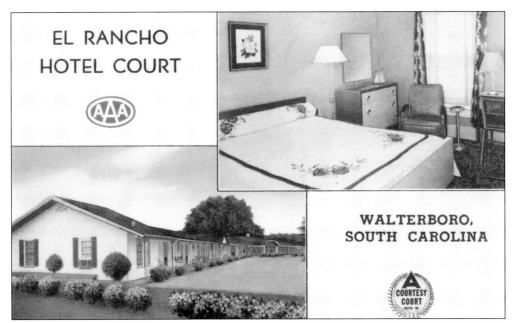

On Highway 15, the El Rancho Hotel Court was well situated. When the Godleys remodeled their "Cottage Camp," the units were designed in the Mexican style, which was a popular motif in the 1940s and 1950s. They advertised that their court had air-conditioned rooms available (with window units), hot water heat, and fully carpeted floors. Today the property is used as short-term rental units and called the Walterboro Inn.

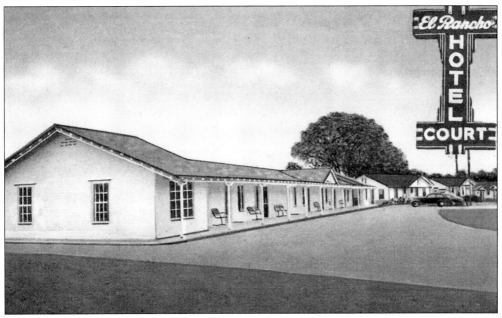

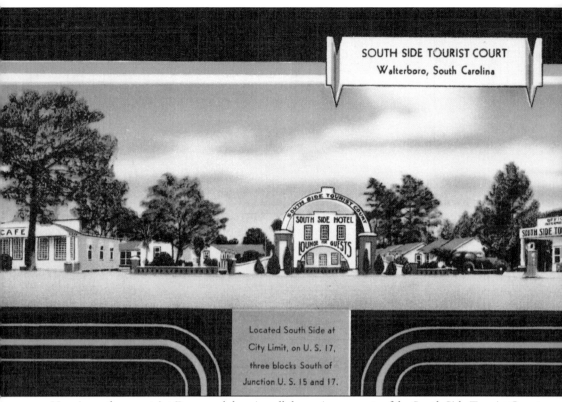

SOUTH SIDE TOURIST COURT
Walterboro, South Carolina

Located South Side at
City Limit, on U. S. 17,
three blocks South of
Junction U. S. 15 and 17.

Here is another great Art Deco card showing all the various aspects of the South Side Tourist Court. The original owners/operators were Mr. and Mrs. P.M. Varn and later, Louis M. Schmonsees. The cottages had hot and cold showers in all the rooms and steam heat. The court offered mail and Western Union service to their guests. Notice the gas station on the right. They advertised, "We service your car while you sleep" and "Sleep in Safety and Comfort without extravagance."

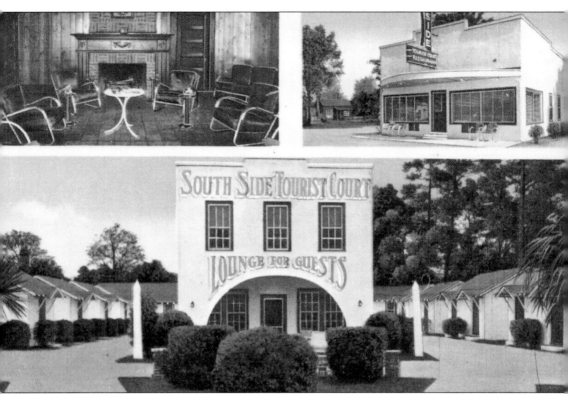

This card shows the remodeled South Side Restaurant, which was managed by O.B. Hiott. The court advertised, "Proper price cafe famous for good food." They were also one of the first places that had a lounge for the guests. It was probably more of a restroom area rather than the "lounges" found at motels today. South Side was demolished, and over the years, various businesses have been situated on the property.

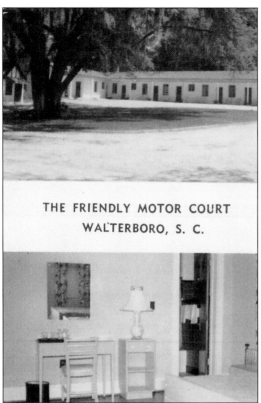

Ed Slotchiver built this motor court about a block away from the Lady Lafayette Hotel and Cottages. He also owned Slotchiver's Department Store on Washington Street. Friendly Motor Court advertised Beauty Rest Mattresses, radio-equipped and soundproof rooms, near fine restaurants and theaters.

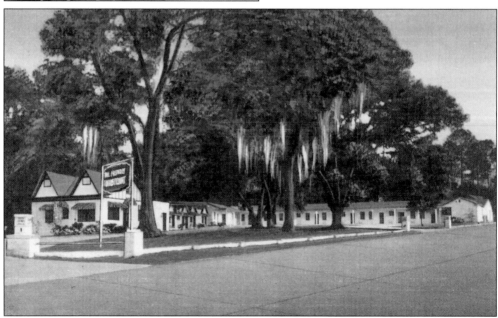

The slogan for Friendly Motel was "A Beautiful Court in a Picturesque Setting." Later it was owned and operated by J. Clouston and G. Cremer. Because of its prime location, the business is still in operation today as the Friendly Inn. There is a Chinese restaurant next door and a Hardee's across the street.

TRAVELERS MOTOR HOTEL

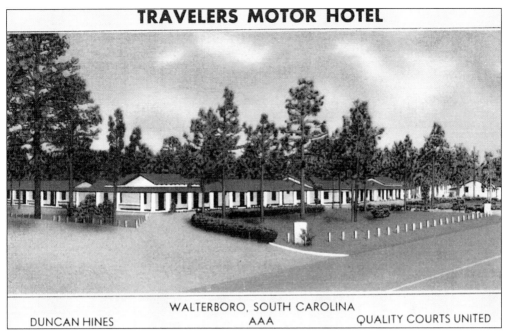

WALTERBORO, SOUTH CAROLINA

DUNCAN HINES AAA QUALITY COURTS UNITED

There were originally 29 rooms in this Arizona ranch style motel. First owned and managed by Mr. and Mrs. James W. Watchman, it was later owned by John and Mary Leonardi. With acres of landscaped grounds, tennis courts, a playground, and large rooms, Traveler's Motel worked to live up to their slogan as "South Carolina's most recommended and outstanding Court." It was once featured in a five-page story in *Red Book Magazine*.

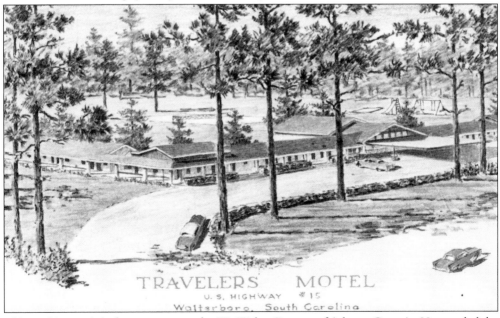

This card is an original crayon graveur by W. Walter Bowers of Atlanta, Georgia. He traveled the East Coast drawing motels and restaurants and publishing them as postcards. Today the property is an empty space with the Traveler's Motel sign near the highway as the only reminder of the motel's existence.

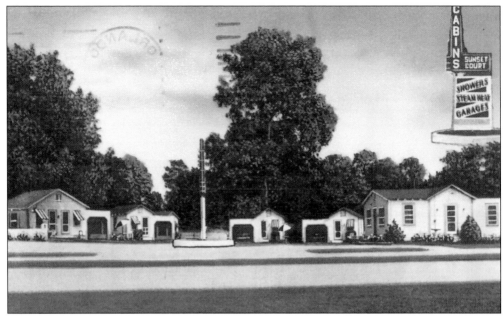

This group of cabins was 1 mile north on Highway 15. Owned and managed by Mr. and Mrs. Raymond Corvez, Sunset Court advertised Innerspring Mattresses, large airy rooms, private showers, and individual attached garages. Their slogan was "Quiet rest assured." Using the same neon sign, Sunset is now apartments owned by Mark Bowers.

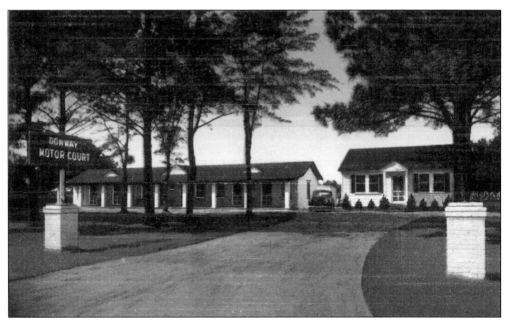

This "Motor Court" was later advertised as the Donway "Motel" and designed in the popular Mexican style with private or connecting baths. They also had modern air-conditioned and heated guest rooms. Wonder what that means? We found the Donway, only 2 miles north on Highway 15, abandoned on the property.

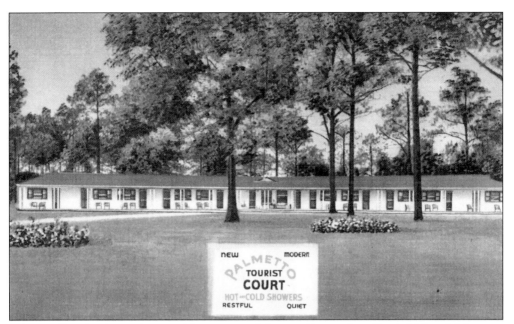

Palmetto Tourist Court shortened its name to Palmetto Court when Frank Hebenthal became the owner/manager. He advertised that the "discriminating tourist can enjoy well ventilated and lighted rooms, colorfully decorated and delightfully furnished." Every room had a private tile bath and was fully carpeted. Today it serves as the Palmetto Boarding Home for the elderly.

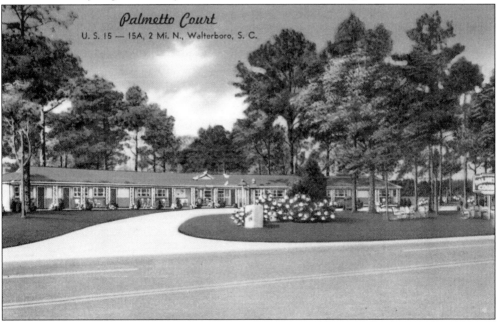

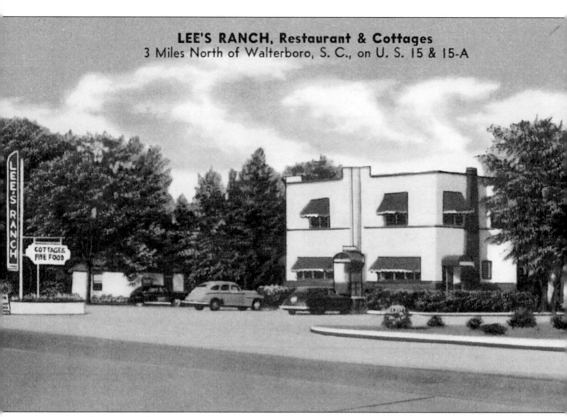

LEE'S RANCH, Restaurant & Cottages
3 Miles North of Walterboro, S. C., on U. S. 15 & 15-A

Located just 3 miles north on Highway 15, Lee's Ranch was later called Lee's Ranch Motor Hotel. It was noted for its excellent food in the dining room, its comfortable, air-conditioned cottages with tiled baths that included a tub or shower, and its "true Southern hospitality." The cottages are still being used today as apartments.

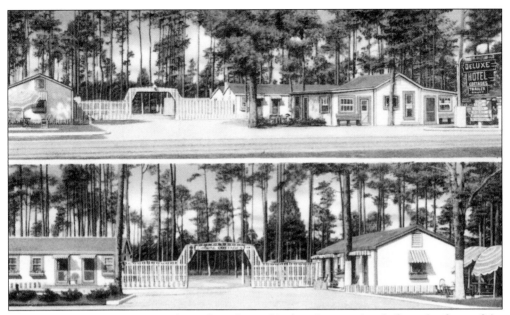

Something that is truly unique about this split card is that the top view is from the front of the Deluxe Cottage Court and the bottom view is looking from inside the court back to the front. Notice the patio with chairs, benches, tables, and umbrellas for shade. They advertised sensible rates with private and connecting baths.

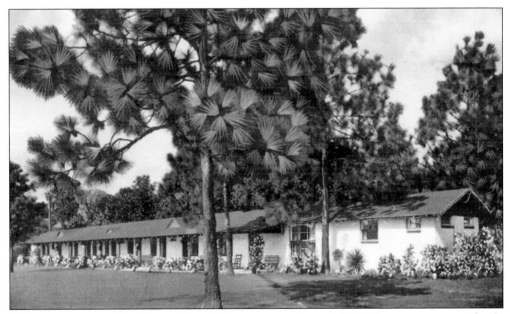

This motor court offered something different to tourists—individual guest rooms or family suites. The rooms had individually controlled heat and private baths. Your rooms could be fan cooled or air conditioned. As it was 4 miles from town, a restaurant was part of the Carolina Motor Court property.

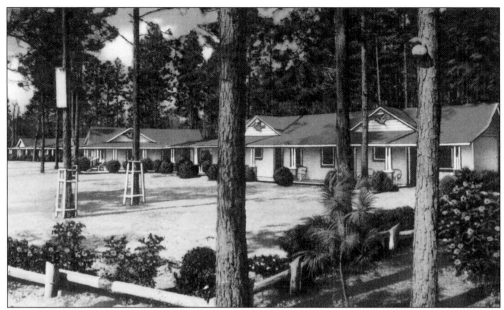

Here is another motor court in Walterboro recommended by Duncan Hines. Their advertisements boasted of modern guest rooms, all with private baths and showers with "instantaneous hot water." They also had a playground for children. Today the Blue Bird Motor Court has been torn down and is an empty property.

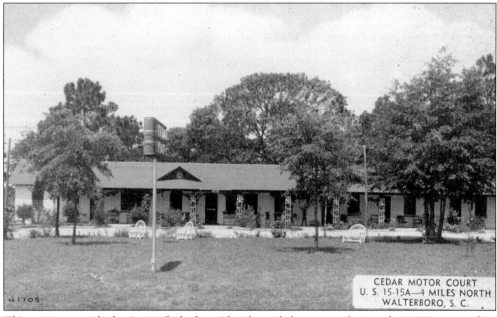

CEDAR MOTOR COURT
U. S. 15-15A—4 MILES NORTH
WALTERBORO, S. C.

This motor court had private tile baths with tubs and showers and steam heat. However, they included something different from the Blue Bird in their advertising by adding "fireproofed rooms with cross ventilation." The Blue Bird and the Cedar Motor Court were 4 miles outside of Walterboro on Highway 15. The Cedar Court was owned and operated by Mr. and Mrs. Sam Augustine, who had two daughters, Beverly and Nina.

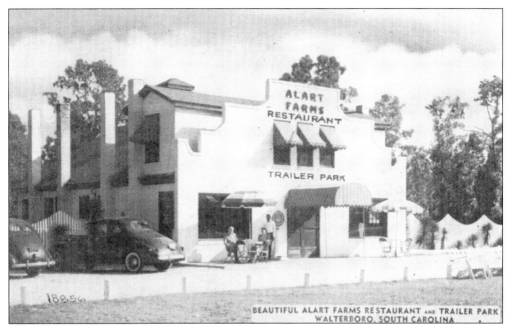

BEAUTIFUL ALART FARMS RESTAURANT and TRAILER PARK
WALTERBORO, SOUTH CAROLINA

Besides the restaurant, Alart Farms advertised as the most complete trailer park between Washington, D.C. and Florida. There were 50 acres of trailer space with a beautiful lounge, recreation and writing rooms, horseshoe pitching, shuffleboard courts, hot showers, and laundry facilities. There were hookups for lights and water at each trailer space. It was about 5 miles out of town.

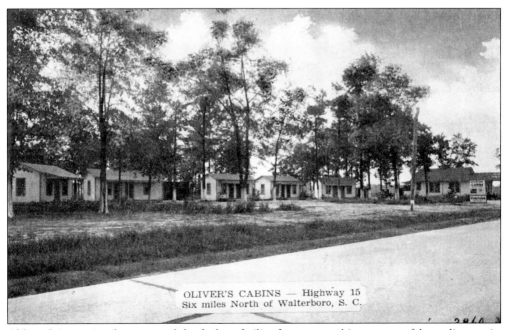

OLIVER'S CABINS — Highway 15
Six miles North of Walterboro, S. C.

Although it was 6 miles away and the farthest facility from town, this was one of the earlier tourist properties near Walterboro. Oliver's Cabins were for "Tourists Only" and boasted that each cabin had good beds and running water with hot and cold showers. They also offered light lunches.

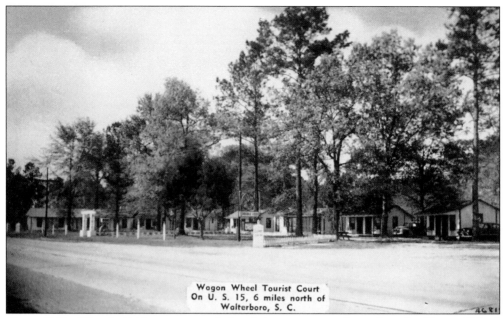

Wagon Wheel Tourist Court
On U. S. 15, 6 miles north of
Walterboro, S. C.

About 1940, Oliver's Cabins was upgraded and the name was changed to the Wagon Wheel Tourist Court. They now advertised air cooled in summer and heated in winter. Their adjoining restaurant offered good meals at budget prices. Wagon Wheel was the only place in the area that also advertised "Children and pets welcome." Today only one abandoned unit is left standing.

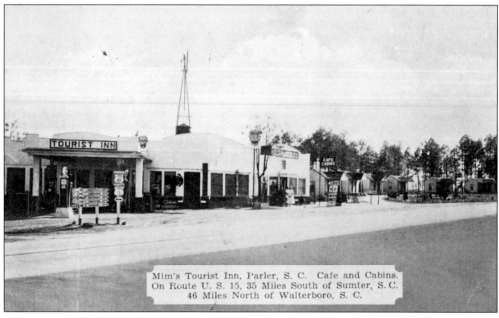

Mim's Tourist Inn, Parler, S. C. Cafe and Cabins.
On Route U. S. 15, 35 Miles South of Sumter, S. C.
46 Miles North of Walterboro, S. C.

This inn was actually in Parler, South Carolina, 46 miles north of Walterboro on Highway 15. It is important to note that Walterboro was such a well-known destination in the Lowcountry when this card was published in the 1930s, that it had become the reference point for other areas.

Six

RIDIN' THE ROADS

In the old South, if you wanted to go over to a neighbor's house for awhile, you went to "sit a spell," but if you had to use some form of transportation, you were "ridin' the roads."

Over the years communities such as Willtown, Radnor, Edmundsbury, Colleton, and Koger have sprung up and disappeared in Colleton County. Other villages that developed were reduced in size with the decline of rice production, the disappearance of the railroads, and modernization. Today these small communities include Jacksonboro, Lodge, Canady's, Ruffin, Green Pond, Ritter, Round O, Hendersonville, and Williams.

Hundreds of plantations were built along the Ashepoo, Combahee, Edisto, and their contributory creeks. Some of these plantations were destroyed during the Revolutionary War. Many more were burned at the end of the Civil War by Sherman's troops. Today there are about 20 plantations still standing. The limited space here cannot do justice to the fascinating history that is associated with the plantations of the Lowcountry.

When the wealthy industrialists (such as Dupont, Guggenheim, Crane, Lawrence, and Hutton) of the North discovered that they could hunt and fish in the Lowcountry during the winter months, they began buying plantations and renovating or building homes and lodges.

Since 1990 many of these wealthy owners have placed part or all of their property on conservation easements to be included in the ACE Basin National Wildlife Refuge, which was created to protect, enhance, and manage the wildlife and their related habitats within the 350,000–acre Ashepoo, Combahee, and Edisto (ACE) Rivers Basin.

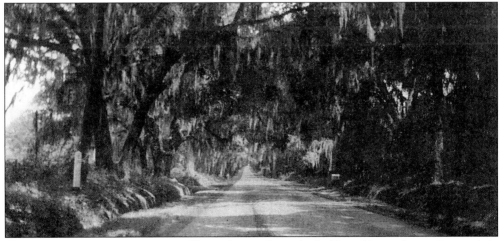

This card, with ancient moss-covered live oaks trees lining both sides of the road, was characteristic of Colleton County and the Lowcountry for many years.

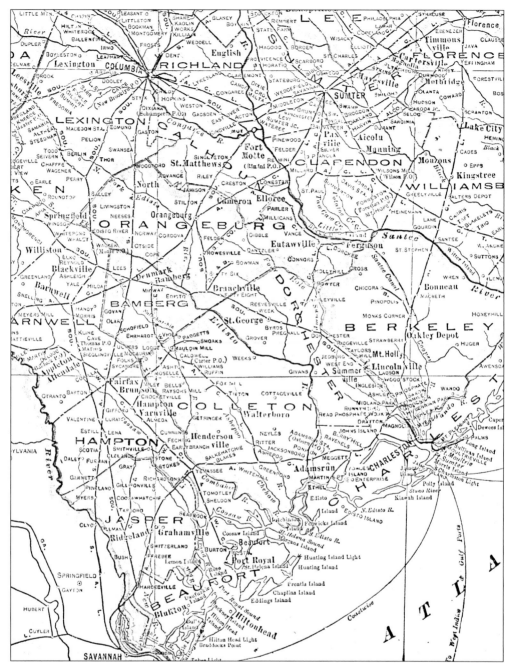

With the exception of the area on and around Edisto Island, little has changed in Colleton County since 1915. The town of Edisto Beach and some of the surrounding area were annexed to Colleton County in 1975. If you will view St. Helena Sound as the border, then the following islands are part of Colleton County: Warren Island, Ashe Island, Bluff Island, Bear Island, Settlement Island, Bennetts Island, Musselboro Island, Hutchinson Island, Sampson Island, Fenwick Island, Otter Island, and Pine Island. With this map you can observe that the creation of Dorchester County was taken almost entirely from Colleton County in 1897.

Ireland Creek, originally Island Creek, flows through Walterboro to the Ashepoo River. At one time it was so wide and deep around the city that people used their boats to fish for redbreast, brim, pike, and catfish. Teenagers would attempt to ski between the bridges and there were even a couple of natural swimming holes. Today it is a trickle of its former beauty, clogged with an overgrowth of vegetation.

The Chee-ha is a tributary that flows near the community of Wiggins, by Tilly Island and Warren Island, into the Combahee River near St. Helena Sound. Christian Herter, secretary of state during the Eisenhower administration, and his family owned Chee-ha Combahee Plantation for many years. E.T.H. Shaffer had a hunting lodge on Tilly Island. Today the area is used for hunting and fishing.

The Edisto [ED-is-TOE] River is the longest free-flowing, black water river in North America. In the fresh water part of the river, one can fish for redbreast, brim, crappie, largemouth bass, and catfish. Rock fish and shad make runs into the freshwater to spawn. Shad roe is a Lowcountry delicacy. Below Willtown Bluff, the river becomes salt water and one can catch shrimp, crabs, oysters, flounder, and spot-tailed bass. Above Edisto Island, the river branches into the North and South forks, flowing on both sides of the Island into the Atlantic Ocean. Today the Edisto and the South fork of the Edisto River serve as one of Colleton County's boundary lines and is the "E" part of the ACE Basin. (Courtesy of Photo Arts, Winnsboro, South Carolina.)

The Ashepoo [ASH-e-POO as in boot] River starts below Walterboro and flows between the communities of Green Pond and Ashepoo above Highway 17 and finally runs into St. Helena Sound. Nearby plantations include Bonnie Doone, Poco Sabo, Lavington, and Airy Hall. Numerous fish are caught in the freshwater part of the river and many alligators make it their home. Today the Ashepoo is the "A" part of the ACE Basin.

The Salkehatchee [SAL as in Paul-ka-HAT-chee] River and the Little Salkehatchee River converge and become the Combahee [KUM-BEE] River. They are the southern boundary of Colleton County and flow into St. Helena Sound at Edisto Island. Laden with fish, the river is a true sportman's paradise and today is the "C" part of the ACE Basin.

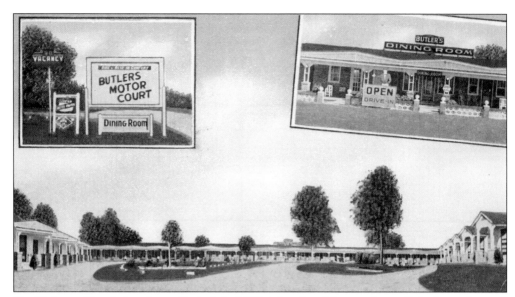

On Highway 17 at Jacksonboro, Butler's had 32 brick units with steam heat, tile baths, and a small dining room. Part of the court burned and the rest was torn down to make room for an Exxon station. Butler's was across from Toomer's Place, which had cabins and a restaurant. Toomers Restaurant is still in business. Jacksonboro was named for John Jackson, who was granted a tract of land on the Edisto River in 1701.

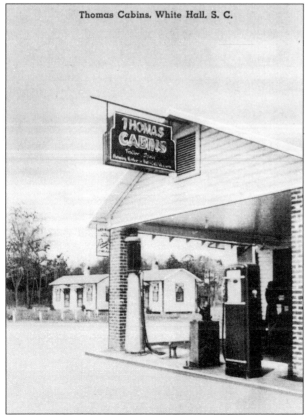

Thomas Cabins, White Hall, S. C.

White Hall Plantation is beside the small village of White Hall. All traces of these cabins and gas station owned by Elliott McTeer have disappeared. In fact, there isn't a store in White Hall today. The area had a post office from 1872 to 1958, a train depot, and a dock for hauling logs to the Combahee River. Recently, some of the local residents restored the post office building.

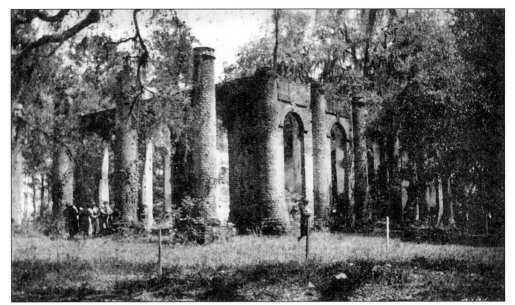

Although Sheldon Church is not in Colleton County, all the older cards say the ruins are either near Walterboro or between Beaufort and Walterboro. The church was originally built as Prince William's Parish Church about 1745. The British burned it in 1779. It was rebuilt in 1826 and then Sherman's troops torched it in 1865. Services are held at the ruins each year on the second Sunday after Easter.

This card might say Walterboro, but the picture could be of many roads in Colleton County. Bayard Wootten was a well-known postcard photographer who traveled throughout the country taking pictures of scenes typical of an area. He seldom photographed well-known spots, but looked for a pleasing artistic setting.

Typical Pine and Dogwood, Walterboro, South Carolina Bayard Wootten

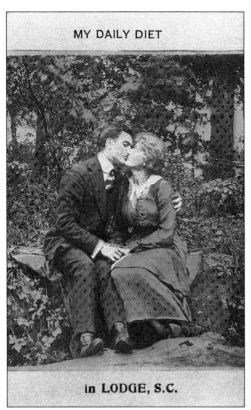

MY DAILY DIET

in LODGE, S.C.

The two cards here are "Lovers" using live models instead of drawn sketches or cartoon characters. The town of Lodge is 22 miles from Walterboro on State Highway 64. It was originally called Hope, but when the post office was set up, they discovered that South Carolina already had a town called Hope. Hope Masonic Lodge 122 is on the main street, so they decided to call the town Lodge.

The ACL Railroad built a line through Lodge in 1898. The tracks were finally removed in 1984 as the train no longer stopped there. The town got electricity in 1937. At one time Lodge had a sawmill and a dress manufacturing plant. Lodge has less than 200 residents with only a volunteer fire department and a softball field and no police force. Today the community is best known for the Old Depot Auction Gallery's monthly auction.

I'd like to hold your hand

in LODGE, S.C.

Greetings from COTTAGEVILLE, S. C.

Here are two generic cards: one stamped Cottageville, which is going east between Walterboro and Summerville on Highway 17A; and one stamped Lodge, which is going west toward Barnwell County on State Highway 64. Notice the hills and the trees that are below the road line. Any hills in the Lowcountry are sand or manmade, trees are close but not that close to the road, and you would have to transport rocks that big to make a wall. Perhaps they needed to look for a swamp, a cypress, or maybe a moss-covered tree to show scenes more typical of the region.

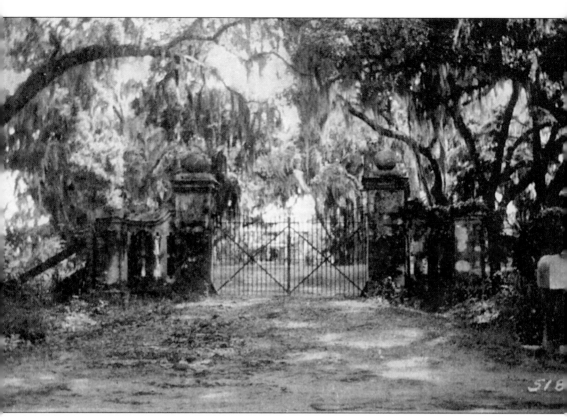

Pon Pon Plantation dates back to the late 1600s. The plantation's lineage began with Sacheverell, then Skirving to Smith to Elliott. William and Ann Smith Elliott changed the name to Oak Lawn. Both were well educated, and together they ran a number of inherited plantations and raised nine children. Oak Lawn became their winter home. When his lands were confiscated during the Civil War, William burned all his crops rather than let them be used by the Union soldiers. He died in Charleston before the plantation was burned in 1865 by Sherman's troops. After the war, Ann and her daughters returned to Oak Lawn and lived in an old washroom/kitchen, as it was the only building left standing on the plantation. They lived there for many years as they began to revive what they could from their lands. At this time the land was still part of Colleton County.

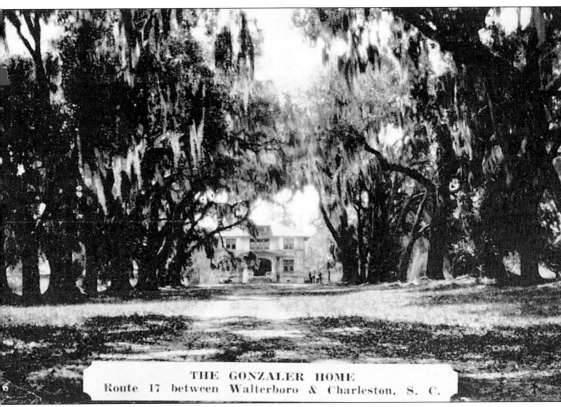

THE GONZALER HOME
Route 17 between Walterboro & Charleston, S. C.

One of William and Ann Elliott's four daughters, Harriott, married a Cuban general named Ambrosio Gonzales. They bought Social Hall plantation from William, but Ambrosio was a mediocre farmer. He went back to Cuba, leaving Harriott with their six children. Harriott died shortly thereafter, and the children were sent to Oak Lawn to be raised by their grandmother and aunts. Ambrose Elliott Gonzales, one of Harriott and Ambrosio's sons, bought Oak Lawn from his aunts in 1910. He built a large Spanish-style home on the site of the old house, which had been destroyed in 1865. Ambrose and his brother, Narciso G., co-founded The *State* newspaper in Columbia. The heirs of Ambrose Gonzales still own the plantation, making it the ancestral plantation to remain the longest in one family than any other in the Lowcountry. Today everyone refers to it as the Gonzales House.

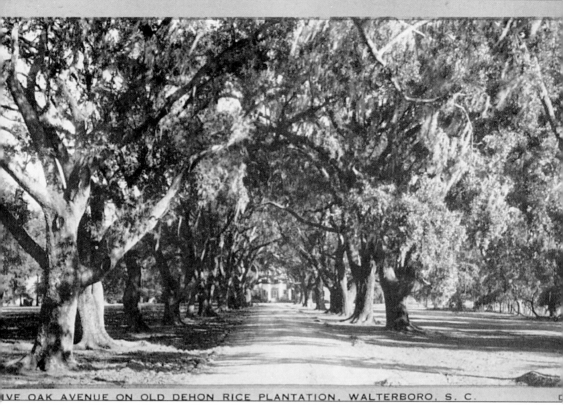

IVE OAK AVENUE ON OLD DEHON RICE PLANTATION, WALTERBORO, S. C.

About 1859, Dr. Theodore DeHon bought part of the Pringle property and named his plantation "DeHon." After the Civil War, it was owned by Cotesworth Pinckney Fishburne, who sold it it E. Louisa Fishburne in 1910. When A.S. Caspary bought over 15,000 acres in Colleton County in 1931, it included eight plantations and a number of land tracts. Two of these plantations were DeHon and Bonnie Doone. Mr. Caspary built his mansion of over 30 rooms where the DeHon plantation home had been before it was burned in 1865 by Sherman's troops. He renamed all his property Bonnie Doone.

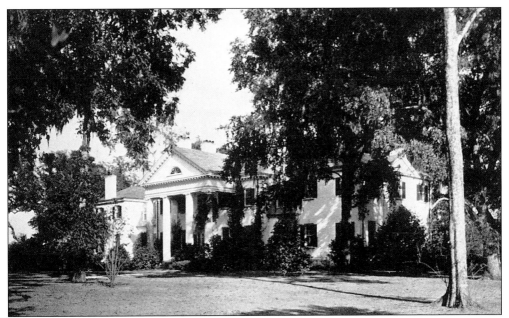

The original Bonnie Doone plantation came from a royal land grant given to William Hopton of Charleston in 1722. Although the original plantation house was destroyed by Sherman's troops in 1865, rice was grown on the plantation until 1911. In early April 1931, Paul Sanders bought Bonnie Doone and by the end of the month had sold it as part of the large land purchase by A.H. Caspary.

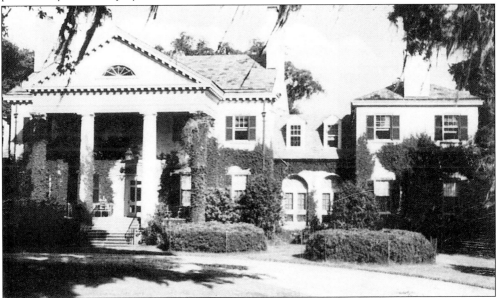

In 1965 the Charleston Presbytery bought Bonnie Doone for a church camp and conference center. In 1978 they sold 132 acres along with the 10,000-square-foot house to the Charleston Baptist Association. In 1987 the church established an endowment fund to preserve the plantation. Today it is called the Bonnie Doone Conference Center, and is open to religious groups and organizations. The Elderhostel programs use this site for retreats during the spring and fall.

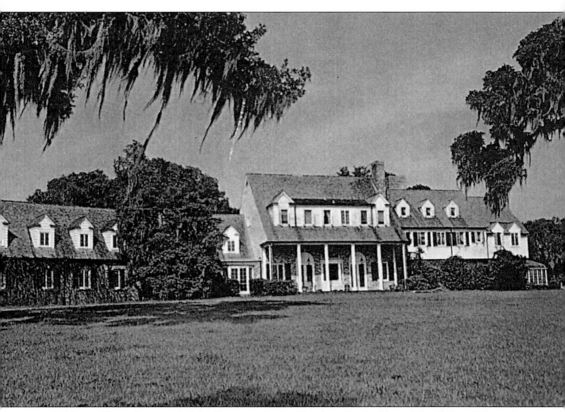

Oakhurst Plantation was originally comprised of land on both sides of the Edisto River. It was first owned by Henry Heyward and Charlotte Manigault. Having no children, Charlotte left the property to the children of Henry's sister, Margaret M. Barnwell. Alice Barnwell, daughter of Margaret, sold Oakhurst to Christopher FitzSimons in 1891. In 1927 he sold Oakhurst and his other plantations, Prospect Hill and Rosemont, to Edward F. Hutton. Franklyn Hutton inherited the property and used Oakhurst as a winter home. He married Edna Woolworth and had one daughter, Barbara Hutton. After a number of owners, it was purchased by G. Herman and Eileen C. Dryer. The 35-room mansion, now called Hutton Plantation, was turned into a bed and breakfast inn for awhile. The house was destroyed by fire in September 1987.

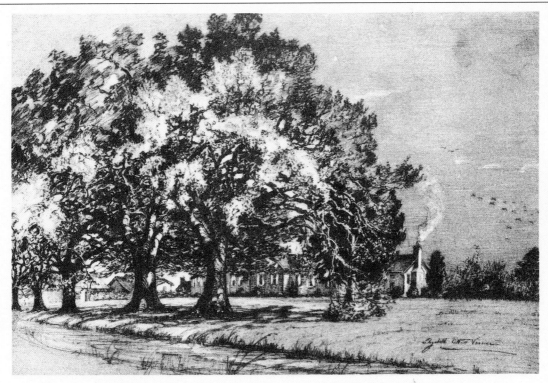

MYRTLE GROVE PLANTATION **WHITE HALL, S.C.**

Myrtle Grove Plantation is located on the Combahee River and was originally owed by Nathaniel Heyward (1766–1851). His grandson, Nathaniel Barnwell Heyward, inherited the property. His great-grandson, Duncan Heyward, who was governor of South Carolina 1903–1907, bought out the other heirs, and by 1910 was the sole owner of Myrtle Grove. He sold it to William Jaycocks in 1918. A consortium sold the property to Joseph S. Stevens, a director of General Foods Corporation, in 1927. He built the current house with six bedrooms and three baths. His estate was sold to Austin and Suzanne B. Iglehart in 1935. It has been sold a number of times since then, but today it is the game preserve that Joseph Stevens wanted it to be. Currently it is owned by W.H. Varn Jr. of Smoaks.

Col. Lewis Morris was stationed in South Carolina during the Revolutionary War, but decided to stay when he married Ann Barnett Elliott. Through her lineage, they acquired property that became known as Hope Plantation. It stayed in the family until 1851, when it was sold to Edward Manigault Barnwell. The house was burned by Union troops in 1865. In 1875 Henry Bischoff combined Hope, Baynard, and Hyawassee Plantations into Rice-Hope Plantation.

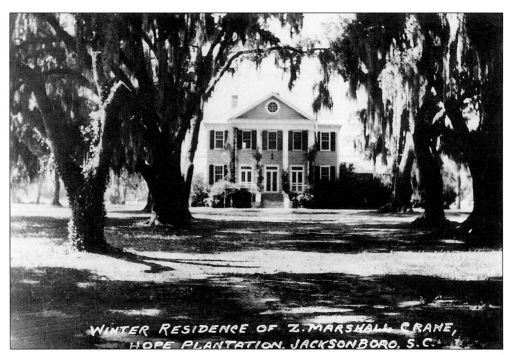

WINTER RESIDENCE OF Z. MARSHALL CRANE, HOPE PLANTATION. JACKSONBORO, S.C.

In 1918 the Bischoff heirs sold the property to Pon Pon Realty Co. Z. Marshall Crane of Crane Paper Company purchased Hope in 1928. He built a lovely two-story house as his winter home. Instead of placing a road up the middle of the avenue of oaks still standing from the original Hope Plantation, he designed the road to go around and behind the oaks to the front of the house.

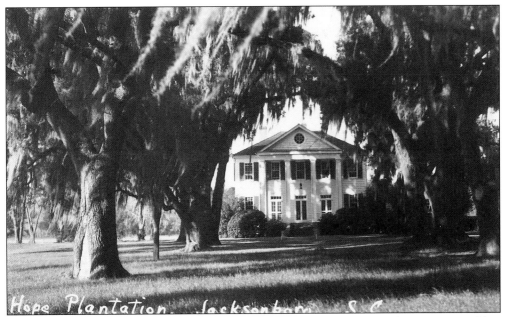

Hope Plantation. Jacksonboro. S.C.

By the time Mr. Crane died, he had accumulated over 4,000 acres, which his executors sold to Max (Major) C. Fleishmann in 1939. P.O. Mead bought Hope in 1952, and his son sold it to the Ashepoo Lumber Co. in 1953. Marion Walter Sams Sr. was the superintendent of Hope Plantation from the early 1930s to the mid-1950s. He planted most of the azaleas, camellias, and fruit trees seen in these cards.

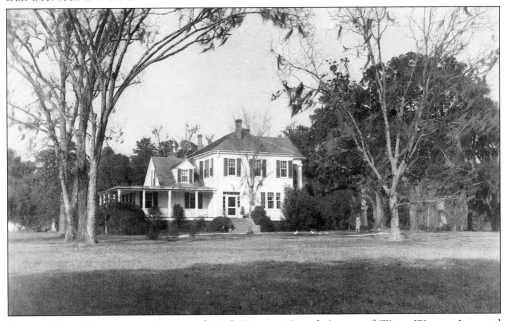

It went through various owners until Ted Turner, vice chairman of Time Warner Inc. and founder of CNN and TBS SuperStation, bought the property in 1978. Mr. Turner has placed all but a few of the plantation's 5,000 acres under easement with the Nature Conservancy, which means that the timber can never be clear cut and the land can never be developed. He has effectively protected Hope Plantation for all time.

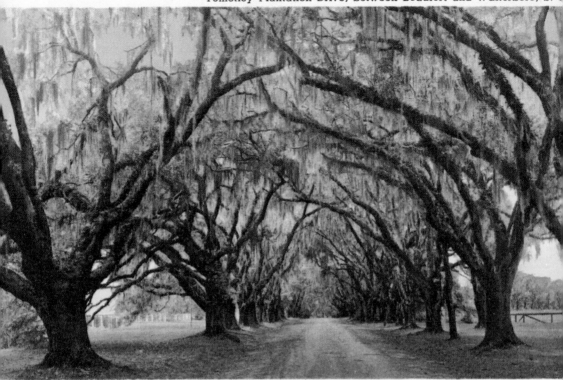

1B3

This card states the location of Tomotley plantation is between Beaufort and Walterboro. While Tomotley I is in Beaufort County, most of the original barony granted to Landgrave Edmund Bellinger in the 1600s was in Colleton County. His other plantations included Tomotley II, Poco Sabo, Whitehouse, Rotherwood, and Bonnie Doone. Tomotley I was purchased by the Izard family in 1755. In 1820, Patience Izard is credited with planting the avenue of live oaks. Patience married Col. Abraham Eustis. James H. Bagget bought Tomotley in 1864. Although it was burned in 1865, there was an intriguing court battle after the Civil War between Bagget and the Eustis heirs that ended up in federal court. The plantation was sold a number of times and is owned today by Mr. and Mrs. William Mixon.

Seven

ON THE BEACH
AT EDISTO

Edisto is one of South Carolina's Sea Islands bordered by the North and South Edisto Rivers, which are connected to the Intracoastal Waterway and the Atlantic Ocean. It has a colorful history which includes fossils from prehistoric animals, the Edistow Indians, the Spaniards, pirates, the Revolutionary War, large indigo and cotton plantations, and the Civil War.

There are two unique things about Edisto Beach that draw thousands of vacationers every year. The first is that the atmosphere is very family oriented and the Island is not over commercialized. Edisto Beach State Park has been in existence for over 60 years. It covers over 1,200 acres, including more than a mile of beach along the ocean. The second is the scenic beauty of Edisto Island. The majority of activities are outdoor related, from deep-sea fishing to crabbing and shrimping in a dozen creeks, from beachcombing for fossils or shells to exploring a part of the ACE Basin by boat, car, bicycle, or foot. Here you can find the salt marsh, rivers, the ocean, endangered species such as the loggerhead sea turtle, a maritime forest, and estuary all on an island about 55 square miles in size.

Numerous cards in this section are artwork by Horace T. Day, a well-known Virginia artist who taught art at Mary Baldwin College. He used vacations and retirement to travel and paint old neighborhoods, landscapes, and historic places. Day was particularly fond of Edisto Beach and visited there a number of times. These cards were all distributed at the Ocean Villa.

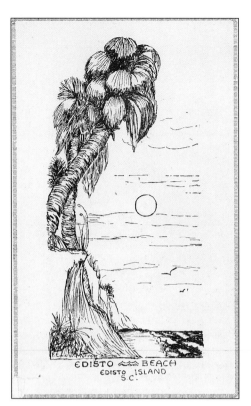

This 1929 artist's pen-and-ink sketch shows the sand dunes that were prevalent before the hurricane of 1940. While many palmetto trees have been destroyed by hurricanes and erosion, they are still the signature tree of Edisto Beach. Sea Oats were almost extinct but are starting to make a comeback because they are protected by laws which forbid picking or doing anything that could harm the plant.

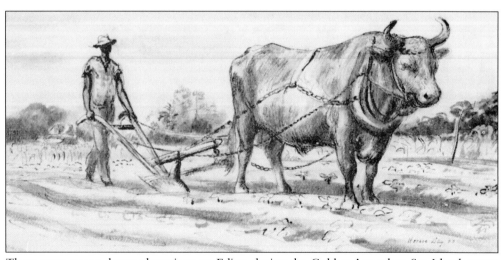

There were over a dozen plantations on Edisto during the Golden Age when Sea Island cotton was the main crop on the Island. After the Civil War, the Freedman's Bureau allowed blacks to acquire land on Edisto, establishing family farms that included from 10 to 60 acres, planting cotton, corn, and other vegetables.

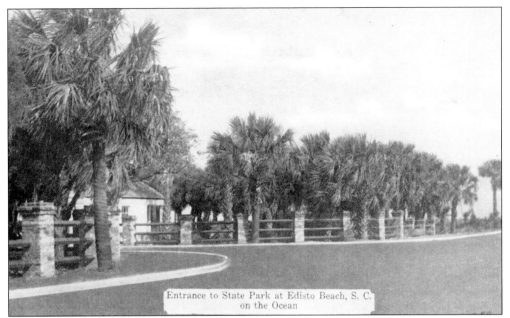

Entrance to State Park at Edisto Beach, S. C.
on the Ocean

Edisto Island is 45 miles east of Walterboro and 45 miles south of Charleston. The park is one of South Carolina's most popular state parks. If you were to ask the people of Colleton County where did they go for a weekend getaway or vacation when they were growing up or today, the majority will say, "Edisto Beach." By the 1940s many Walterboro residents owned beachfront property and built "summer cottages," sleeping as many as beds and cots would allow.

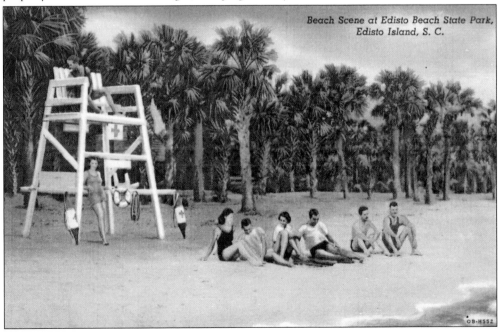

Beach Scene at Edisto Beach State Park,
Edisto Island, S. C.

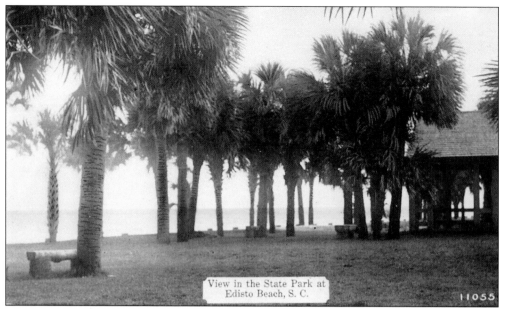

View in the State Park at
Edisto Beach, S. C.

11055

Edisto Beach State Park opened in the late 1930s and was constructed by the Civilian Conservation Corps. Shelters (as seen here), restrooms, a park bathhouse, and camper sites were constructed on the ocean side. Today it includes water and electric hook-ups for self-contained campers. They have built five two-bedroom cabins overlooking the salt marsh. Although the park is open year-round, the main vacation season begins at Easter and goes through Labor Day.

Shrimp trawlers go out daily when weather permits. They catch oysters in season and shrimp and crabs year-round. In the summer they fish for flounder; in the winter they switch to trout. There are a few restaurants right on the docks that get a daily delivery of fresh seafood.

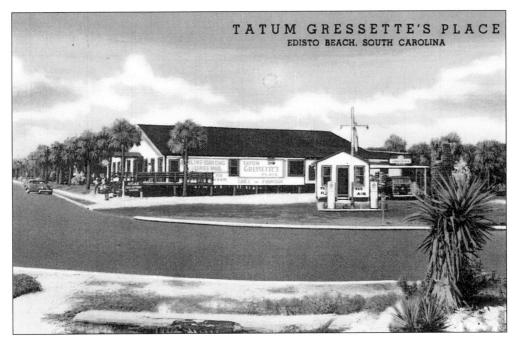

TATUM GRESSETTE'S PLACE
EDISTO BEACH, SOUTH CAROLINA

Tatum Gressett was the athletic director for the University of South Carolina for many years. He opened Tatum Gressette's Place in the 1930s. It had a bowling alley with a snack bar, a grocery store, a post office, and a large dance floor with an old-fashioned Wurlitzer jukebox. If you grew up during the 1940s, '50s, or '60s, you probably shagged to beach music at "the bowling alley."

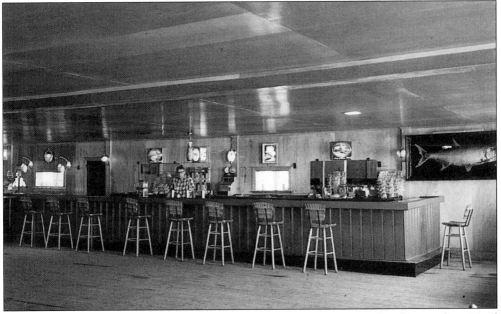

The Collins family eventually bought Gressette's Place and made it part of Collins Pavilion. Until it burned down, it was the recreation headquarters on the beach. If you were with your parents, a teenager, a young single, or a couple, this was the place to go when you were at Edisto. After the fire, the property was sold, and a BP station is on the corner today.

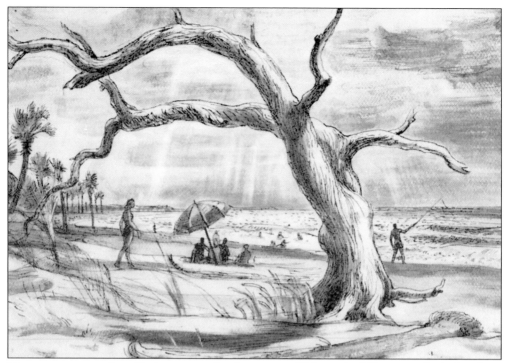

Here are two examples of "what you see is what you get." The main difference today is that there are not as many palmetto trees in the park as there used to be and a few more houses are on the beach. You will still find children building sand castles, people walking their dogs, fishing, sitting in chairs, and playing in the water.

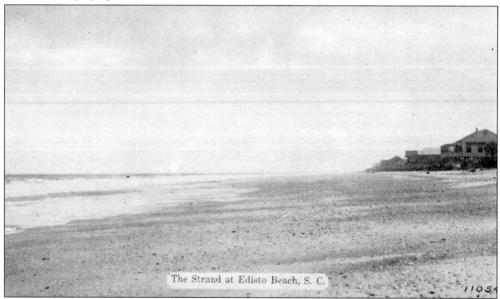

The Strand at Edisto Beach, S. C.

You won't find any business ventures here, just sand, water, and the sun. It is along this stretch of beach that many of the endangered loggerhead sea turtles make their way ashore and lay their nests of eggs. There is a volunteer turtle patrol program at Edisto Beach that helps protect the nests and the baby turtles as they attempt to make their way back to the ocean.

The Jungle Road at Edisto Beach, S. C.
on the Ocean

Typical of many roads in the Lowcountry, the trees grow over the Jungle Road. On cloudy days, you need to turn carlights on for safe driving. A short distance from the beach, it was the second road on the Island that was paved. SC Highway 174, which connects the Island with the mainland, was the first paved road. It was a number of years later before any side streets saw pavement.

The sea marsh, which can stretch as far as the eye can see, is one of the beautiful sights on the Island. It is the home of much wildlife. Edisto is a real haven for birdwatchers. Over 200 varieties of birds can be found here, from southern bald eagles, egrets, blue herons, and sandpipers to bluebirds, red-winged black birds, and hummingbirds.

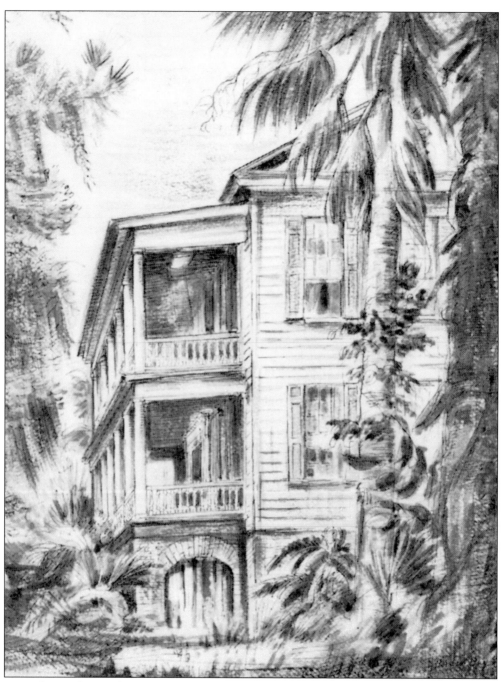

Located near the South Edisto River on St. Pierre's Creek, the Mikell House was built about 1840. Patterned after homes in the West Indies, it had 12 rooms with tall ceilings and large windows to allow for airiness and to catch the breezes. The Mikells, as planters of long staple cotton that grew so well on Edisto Island, became very wealthy. They also owned a magnificent mansion on Rutledge Avenue in Charleston. When General Lee ordered everyone to leave Edisto in 1861, I. Jenkins Mikell burned his storehouse of cotton rather than see it used by the enemy. Edisto Island was occupied by Union troops throughout the Civil War.

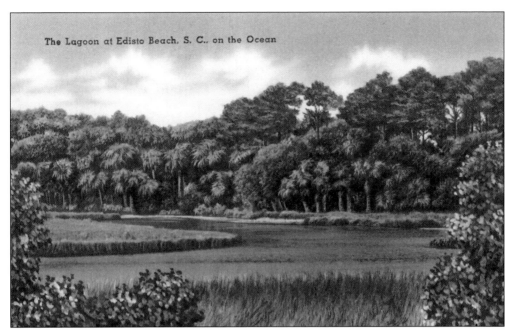

The Lagoon at Edisto Beach, S. C., on the Ocean

Edisto Island is home to many of the 27 endangered species of plants and animals that are protected as part of the ACE Basin. This lagoon stays lush green year-round. It has become the feeding place for hundreds of wood ibis, a graceful long-legged bird with black and white feathers. It is also typical to see alligators, deer, turkeys, brown pelicans, foxes, and bobcats in this area.

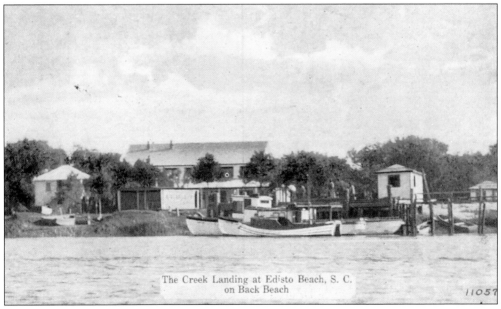

The Creek Landing at Edisto Beach, S. C.
on Back Beach

11057

Boat landings are very important to the Island's way of life. Before bridges were built, boats were the only mode of transportation on and off the Island. Steamships made port at Edisto when the planters' products were shipped overseas. Creek Landing is used more by commercial fisherman and the offshore fishing charters. They have river cruise charters available as well as water nature tours into the ACE Basin.

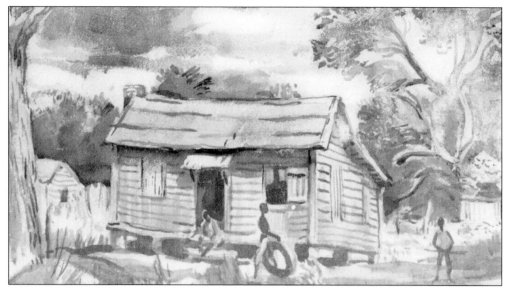

This was typical of cabin structures on Edisto. Most of them were white clapboard with the trim around the doors and windows painted "haint blue" or other bright colors to keep the "haints," or evil spirits, out. Most blacks now have built better houses using more of the modern amenities. However, you can still see similar cabins here and there around the Island, owned by people who prefer a simpler way of life.

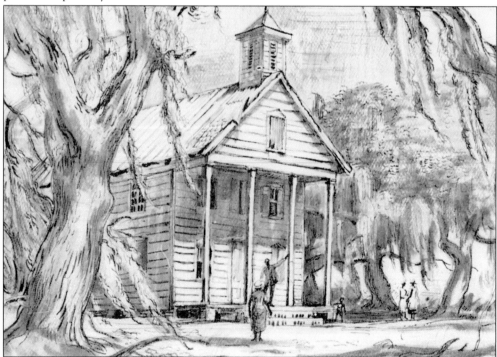

There are about 12 black churches on Edisto. A larger church was built for the four main denominations of Presbyterian, Baptist, Methodist, and Episcopalian. Smaller churches are scattered around the Island and affiliated with one of these denominations. They are called "Sister Churches." Here is one of the black churches that dates back to the 1800s.

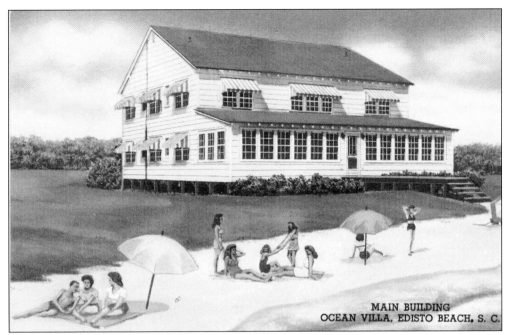

MAIN BUILDING
OCEAN VILLA, EDISTO BEACH, S. C.

This building was originally built as a "summer cottage" for Walterboro residents and in 1943 was bought by Sam Siegel. It had 11 rooms, 2 dining rooms, and a large enclosed porch. According to Mr. Siegel, it was full most of the time, sometimes with total strangers to his family.

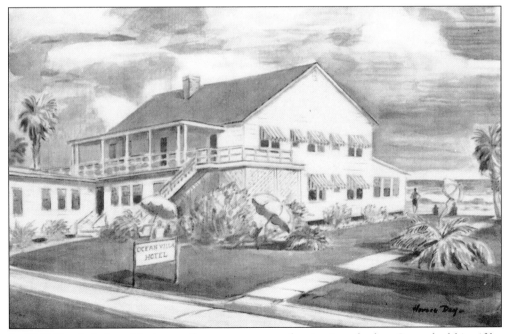

In 1948 Harvie Lybrand had a small restaurant across the street, and when Sam asked him if he were interested in having a boardinghouse near the restaurant, Mr. Lybrand said yes, but he didn't have the cash on hand. Mr. Siegel offered his hand, and with a handshake, the Ocean Villa was created. Mr. Lybrand was also mayor of Edisto Beach for many years.

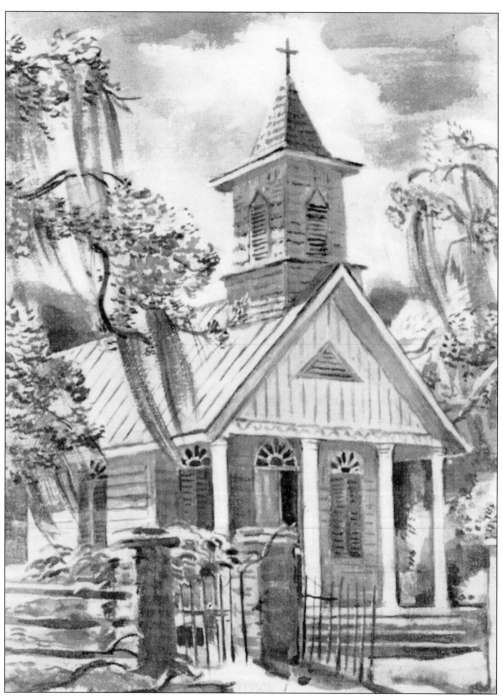

The Trinity Episcopal Church was founded in 1774. The first building was replaced with a new one in 1840. Along with other churches located on Highway 174, it was used by the Confederate and Union armies during the Civil War. Because of its tall steeple, it was used mainly as an observation post. A fire destroyed the church in 1876, and a new building was completed in 1880. The hurricane of 1893 almost destroyed the building, but it was rebuilt as seen here.

Although the Presbyterian church was founded at Edisto by 1710, Henry Bower granted the church 300 acres in 1717. This impressive church sanctuary was built about 1831 from money donated by the wealthy Sea Island cotton planters on Edisto to replace an older building.

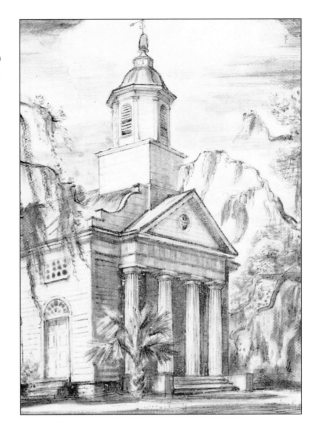

Here is a early real photo card showing the inside of the church facing the altar. There is a cemetery in back of the church with many interesting monuments. Legend has it that at one mausoleum, where the door cannot be closed, a young girl who was mistakenly buried alive keeps the door open so that her fate can never happen again.

BIBLIOGRAPHY

Andrews, Barbara. *A Directory of Post Cards, Artists, Publishers and Trademarks.* Irving, TX, Little Red Caboose, 1975.

Allmen, Diane. *The Official Price Guide Postcards, First Edition.* New York, NY, House of Collectibles, 1991.

Baldwin, William P. III. *Low Country Day Trips.* Greensboro, NC: Legacy Publications, 1993.

Bryan, Evelyn McDaniel Frazier. *Colleton County, S.C.: A History of the First 160 Years/1670–1830.* Jacksonville, FL: Florentine Press, 1993.

City Directories of Walterboro and Charleston, South Carolina. Nelsons' Baldwin Directory Company, Inc., 1956.

Colleton Artists Guild. *Backward Glances—Colleton County.* Walterboro, SC: *Press and Standard,* 1976.

Colleton Artists Guild. *Backward Glances Vol. 2—Colleton County.* Walterboro, SC: *Press and Standard,* 1978.

Colleton County Historical and Preservation Society. *Colleton County, South Carolina: A Pictorial History.* Dallas, TX: Taylor Publishing Company, 1994.

Fishburne, Lucius, G. *Plantation Notes St. Bartholomew's Parish.* Walterboro, SC: Colleton County Library, Unpublished.

Glover, Beulah. *Narratives of Colleton County South Carolina.* [First Printing 1962] Spartanburg, SC: Reprint Company, 1996.

Glover, Beulah. *Tribute to Yesterday.* Walterboro, SC: *Press and Standard,* 1980.

Glover, Beulah, and Leslie Montgomery Rentz. *Walterboro, People and Places before 1900.* Walterboro, SC: Gahagan Print Shop, 1986.

Graydon, Nell S. *Tales of Edisto.* First Revised Edition. Orangeburg, SC: Sandlapper Publishing, Inc., 1986.

Linder, Suzanne Cameron. *Historical Atlas of the Rice Plantations of the Ace River Basin (1860).* Columbia, SC: South Carolina Department of Archives and History, 1995.

Lowcountry & Resort Islands Tourism Commission. *Lowcountry Guidebook.* Beaufort, SC: Sands Publishing Company, 1996.

Moore, John Hammond, Ed. *South Carolina in the 1880s: A Gazetteer.* Orangeburg, SC: Sandlapper Publishing, Inc., 1989.

Press and Standard newspaper. Walterboro, SC. Articles from 1890 to 1998.

Puckette, Clara Childs. *Edisto, A Sea Island Principality.* Johns Island, SC: Seaforth Publications, 1978.

Shaffer, E.T.H. *Walterboro, South Carolina.* From the *Southern Information Booklet* series. Charleston, SC: Southern Printing & Publishing Co., 1929.

Stadtmiller, Bernard. *Postcard Collecting, A Fun Investment.* Palm Bay, FL, 1973.

Stauffer, Michael E. *The Formation of Counties in South Carolina.* Columbia, SC: South Carolina Department of Archives and History, 1994.

Stets, Robert J. Sr., Ed. *South Carolina Postal History.* Lake Oswego, OR, Raven Press, 1988.

Telephone Directory, Walterboro, SC, South Carolina Continental Telephone Company, 1948.

Walterboro-Colleton Chamber of Commerce.

Warren, J.L.B. *Little Pieces on Doings in the Nineties.* Walterboro, SC: *Press and Standard,* 1939.

Wright, Cantey Holmes. *The Edisto Book.* Columbia, SC: Mac Kohn Printing, 1988.

INDEX